# Forgotten Tales of
# New York

# Forgotten Tales of
# New York

## Melanie Zimmer

Charleston    London

THE
History
PRESS

Published by The History Press
Charleston, SC 29403
www.historypress.net

Copyright © 2009 by Melanie Zimmer
All rights reserved

First published 2009

Manufactured in the United States

ISBN 978.1.59629.678.7

Library of Congress CIP data applied for.

# Contents

# ACKNOWLEDGEMENTS

During the course of writing *Forgotten Tales of New York*, I was helped by many fine people who unselfishly offered their knowledge about history and New York State. I will attempt to thank them all.

Ellen Murphy of the Vernon Historical Society supplied a manuscript by Breta Lewis, Dr. Lewis's daughter, called "Vernon Doctors," which I used as the basis of the section on Dr. Lewis and the Oneida County Medical Society. Thank you to Sue Bork of the Tabernacle Baptist Church in Utica for supplying me with historical material about Cephas Bennett. Thank you to the people of Peterboro, who provided me with information on Greene Smith. Thank you to Carol Rubenstein, who granted me an interview about her work on the poems of Borneo. Thank you to Joanne Larson of the Gorman Foundation, who granted me an interview about Alice Gorman. Thank you to Karen Osburn at the Geneva Historical Society for information regarding the Louis-Philippe painting hanging over the mantle in the Rose Hill Mansion and to the docent who originally told me the story. The information on Louis-Philippe in New York State was drawn largely from Morris Bishop's article "Louis Philippe in America" (*American Heritage* magazine, April 1969). Doris Wolf contributed some marvelous tales of Waterloo. The racehorse story came from *Becker's History of Waterloo*. Information on the world's largest

puzzle came from an exhibit at the Mansion House. Dr. Tony Wonderley, curator of the Oneida Community Mansion House, provided me with additional information regarding the puzzle when I was unable to discover Ray's last name (it was Noyes). Dr. Sally Roesch Wagner from the Gage Foundation provided the interesting tale of how the foundation originated, as well as information on Matilda Joslyn Gage. Thank you Dr. Daniel Ward, who once showed me the building that housed the eighth wonder of the world.

Thank you to Dave Fuhrer, proprietor of The Only Café in Vernon, for the story of the Republican flagpole. A special thanks to Francis Zimmer, my husband, for discovering the Universal Friend while I was indulging in a sumptuous chocolate mousse cake with a friend of mine. Thank you to the Waterloo Historical Society Archives for information on the Railroad Mill Fire, Seth Genung's expandable table and the information on Louise Scherbyn. A special thanks to Tanya Warren at the Waterloo Historical Society Archives for drawing my attention to Louise Scherbyn. The archives have numerous boxes of material on Scherbyn, but before now, they have gone largely unnoticed. Tanya told me about Louise and how her story needed to be heard, and indeed it does. Thank you also to Tanya for showing me the human skull in her collection and providing the information from the Waterloo Historical Society Archives about the bone-stealing dog. Thank you to any source that has preferred to remain unnamed. To any source that I have unwittingly omitted, my profound thanks and deepest apologies.

# INTRODUCTION

W elcome to New York! The history of New York State comprises both what is written within our history books and what is unwritten. Without doubt, we recall the names and lives of famous men and women. We remember the major battles and events of our state's past; but more often than not, the story of the average man or woman is completely forgotten. This book hopes to tell a few of those stories and several unusual, little-remembered stories of famous individuals, as well. As often as not, I think we may find the average man or woman in these tales hardly average at all. While all of the monumental stories of New York's history should not be set aside, the little-known stories can help us remember our state's history a bit differently and, perhaps, in a way that is fuller, richer and more human. We cannot forget that every one of us, no matter how insignificant we may feel, is shaping history each day as we live. The world would not be exactly the same without us.

The stories you will discover in this book are all pieces of history—not from a faraway or exotic land, but from here in our very own New York State. These stories focus on the multitude of places that lie outside of the metropolis of New York City—that is, these are primarily stories of Upstate New York. Most are little known, and some were known by

only a few prior to this printing. All, I hope, are entertaining. The stories, as you can see from the acknowledgments, were taken from a wide variety of sources, and the tales themselves are equally as diverse. I hope that between the covers of this book you discover a new New York, a place of unusual events and people.

# What's in a Name?

Anyone who has ever perused a map of New York State could easily imagine a world itinerary without ever leaving the boundaries of New York. A traveler is likely to find names such as Troy, Rome, Cicero, Syracuse, Utica, Paris, Naples, Athens, Attica, Greece, Sparta, Florence, Damascus, Barcelona, Phoenicia, Ithaca and Jerusalem, among many others. Any visitor, or even a resident for that matter, might begin to wonder how and why New York's cities and villages took on such an international flavor.

It all began with the Revolutionary War. The United States Congress had promised every soldier one hundred acres of land if he served in the war until a peace treaty was ratified. On September 16, 1776, Congress passed a provision requiring that eighty-eight battalions of soldiers be enlisted. These eighty-eight battalions were divided among the states, and New York was required to raise four of them. However, by March 1781, it had only formed two battalions; it seems that interest in serving in the Revolutionary War had limited appeal among many New Yorkers. To raise the two additional battalions of men, New York offered an appealing incentive. In addition to the one hundred acres of land a soldier would receive from the United States, New York would offer an additional five hundred acres for the common soldier who served for three years. These men became

known as the New York Line. Commissioned officers would receive between one and five thousand acres of land depending on their rank. The generous incentive worked, and New York was able to fulfill its quota of men to aid in the Revolution.

Though the war ended in September 1783, lots were not distributed quickly. Land was set aside in originally twenty-five military tract townships, but later three more were added to accommodate the number of claims on it. To further complicate matters, before the land was distributed, treaties with the Onondaga and Cayuga Indians were required. Then the land had to be surveyed and divided into lots. In each township there were ninety-four deeded lots, and six were reserved for schools, churches or other public needs. At long last, in the middle of 1790, the names of soldiers were dropped into a barrel and then drawn—lots were simultaneously drawn from the township box.

At first the military tract townships were only designated with numbers; however, in time, they were given names, but they do not correspond exactly to current towns. The names of the twenty-eight military tract townships were Lysander, Hannibal, Cato, Brutus, Camillus, Cicero, Manlius, Aurelius, Marcellus, Pompey, Romulus, Scipio, Sempronius, Tully, Fabius, Ovid, Milton, Locke, Homer, Solon, Hector, Ulysses, Dryden, Virgil, Cincinnatus, Junius, Galen and Sterling. Historically, the lots were believed to have been named

by New York surveyor general Simeon De Witt, but now it is believed that they were named by a clerk in his office, Harpur, an Irish immigrant and, at one point, a professor of the classics at King's College in New York. It is believed that Harpur's love of the classics spawned the naming of countless localities. Also, the naming of New York State cities, towns and villages may have been influenced by Romanticism and the neoclassical revivalism predominant at the time. Some believe that the 1789 naming of Troy helped forge the way.

The story of the naming of Delhi is rather unusual. Delhi, as with many New York localities, is not pronounced like its namesake, but rather as "dell-high." Cairo, for another example, is not pronounced like the Egyptian city, but rather as "kay-roh." The story for Delhi goes like this: Judge Foote of the Ulster County legislature was a staunch supporter of the formation of the town and, in being so, was appointed to name it. Foote went by the nickname of "the Great Mogul," and so it was suggested to him that he name the community Delhi after the Mogul city. He obliged. However, General Erastus Root, among others, had wished the town to be called Mapleton, no doubt after the trees that were prevalent there. In a form of protest against the new name, Root cried, "Del-hi-hel-high! Better call it Foote-high!" Perhaps this accounts for the unusual pronunciation in that particular locality.

## ONEIDA CASTLE: FORSAKEN CAPITAL

One option for the location of capital of New York State was Oneida Castle, previously known as Oneida Castleton. It was considered because of its location—that is, Oneida Castle is the approximate center of New York State. In fact, not only was it considered for the location of New York's state capital on three occasions, but also oral history claims work had actually begun. Local historians say that a governor's mansion was built in anticipation of Oneida Castle's selection. It stands on Route 5 today, and its address is 50 Seneca Street in Oneida Castle. Though now privately owned, the building was for a time a bed-and-breakfast called the Governor's House and is a four-story brick building in the Federal style. It bears a date of 1826,

though the owner says that the locals claim that it was built in 1846.

A mustering ground was also created in Oneida Castle, and that still exists today, serving as a local park. It is said that the grounds were used by soldiers during the Revolutionary War. Local historian Luette Hill says that the park is the exact geographical center of New York State. It is located next to the Cochran Memorial Presbyterian Church. The corner of the park is located at the intersection of Third and, aptly, State Streets, otherwise known as Route 365. The cross streets are numerical, as would be expected in a capital city.

## LOUIS-PHILIPPE IN NEW YORK

One day when I was in Geneva, New York, on the Finger Lakes, I stopped at the Rose Hill Mansion, a restored Greek Revival home furnished in the Empire style. At the end of the tour, we were in the music room, where a large portrait of a man hung over the fireplace. I inquired as to whom the man might be and was told that he was Louis-Philippe, king of the French. I felt a little stunned and asked why a French king would be displayed over the mantel of this New York home. The docent explained that Louis-Philippe had actually been traveling in New York at one point and that stories of him existed.

One day, she said, a relative of a Geneva area couple traveled to France, and there was what she described

as a "garage sale" in the Tuileries. There the gentleman discovered this painting of Louis-Philippe. She said that the Citizen King, as he was called, was so unpopular that his portrait had practically no commercial value, so he purchased it for a song and much later it was donated to the Rose Hill Mansion. It was installed over the mantle and became part of the permanent exhibit.

Upon further investigation through the Geneva Historical Society, I learned a bit more about the painting. It was originally purchased in 1848 following the two-day revolution and Louis-Philippe's flight into exile in England. The painting was sold at an auction along with the furnishings of the royal family at the Tuileries, where they had resided. Part of the purchaser's family had lived in Geneva since 1836. The painting was hung in the Clark home on South Main Street until 1975, when it was donated to the Rose Hill Mansion. Today the portrait hangs over the mantle in the music room of the mansion.

According to the Geneva Historical Society, Louis-Philippe and his two brothers arrived in Geneva in the summer of 1797 and were said to have stayed at the Geneva Hotel, which is now the Pulteney Apartments. The Geneva Hotel was quite new then. It had only been completed in the fall of 1796.

Indeed, Louis-Philippe did visit America long before he became the king of the French and left a diary of his experiences. His brother, the Duc de Montpensier, was a skillful watercolorist and painted and sketched many of

the sights the brothers saw. In fact, Montpensier painted Niagara Falls, which they viewed in June 1797, and later it appears that Louis-Philippe commissioned Romney to paint the three princes in front of the upper falls of the Genesee in Rochester using one of Montpensier's gouaches as a source. Montpensier's original is now lost.

However, the three brothers were not ordinary tourists—they were exiles. Louis-Philippe d' Orléans left for America on September 24, 1796, aboard the *America*, accompanied by his servant Beaudoin. Louis-Philippe was twenty-three years old. The journey was not necessarily one of his own choosing, though perhaps it was better than the alternative. Louis-Philippe was a prince by blood, but he was not of the House of Bourbon but rather of the lesser House of Orléans, and upon his father's death, Louis-Philippe became the Duke of Orléans. Louis-Philippe had joined the army as a young man and is said to have served quite valiantly. He served as a lieutenant general and fought the Austrians but then proceeded to switch sides. Since that fateful decision, Louis-Philippe lived as an exile and an outcast, fleeing France in April 1793.

Louis-Philippe lived in Switzerland, Lapland, Germany, Denmark and Norway. Often he lived in the crudest of circumstances, sleeping in barns or wherever he could and always under an assumed name. Sometimes he taught French or mathematics to obtain money, and once he was turned away from a monastery because they thought he was a vagrant, so lowly was his condition. Louis-Philippe's

mother found sanctuary from prison and execution in a certain nursing home, but Louis-Philippe's younger brothers, Montpensier and Beaujolais, were imprisoned. However, an agreement was at last made with the Directoire that if Louis-Philippe and his two brothers were to leave for America, they would be released.

To please his mother and free his brethren, Louis-Philippe agreed and set sail from Hamburg on a ship fittingly called the *America*, arriving in Philadelphia. Louis-Philippe used the name "Mr. Orleans" in America, though the captain of the *America* had been quick to spread the news of the prince's arrival. His two brothers subsequently arrived incognito on the Swedish ship *Jupiter* in November. When they arrived, Montpensier and Beaujolais were only twenty-one and seventeen years old, respectively. The three of them resided in a house in Philadelphia at Fourth and Prune Streets.

In Philadelphia, Louis-Philippe was disappointed in the rejection he received in the courtship of a young woman, Miss Abby Willings. Miss Willings's father rejected Louis-Philippe's marriage proposal on two counts. First, Louis-Philippe was currently destitute and therefore an unfitting match for Miss Willings. In the event that Louis-Philippe were to recover his position and family fortune, Miss Willings, her father thought, would not be suitable as a bride to Louis-Philippe, and so the proposal was said to be rejected. Louis-Philippe decided that the brothers would use their time to journey across America, a country

so young and novel that it proved fascinating to many Europeans.

Though the family had been one of the wealthiest in Europe, the three princes and their servant were, in fact, quite without. The two younger princes had brought a small sum of money, and Louis-Philippe was able to obtain credit through a financier friend. They purchased four horses as transport and departed with $1,218.50 to sustain the four of them in their journey across America. They dressed themselves in buckskins to resemble trappers but carried their satin suits embellished with ruffles tucked away in their saddlebags so they could make a dashing appearance if the need were to arise. Their dog, who had previously been imprisoned with the younger brothers, accompanied them on their journey.

The three young men traveled down to Washington, D.C., where the President's House, as it was called, was under construction. Then they continued on to Mount Vernon and were announced to George Washington as the three Equalities (no doubt after their father, Citoyen Égalité). While there, they expressed their interest in seeing America, and George Washington himself drew an itinerary in red ink on a copy of Abraham Bradley's map of the United States. Louis-Philippe kept this map and would display it to visiting Americans while he was king, but for now this line on the map was the plan for the three princes' travels.

The itinerary was quite extensive, especially back when America was so young and roads were often rudimentary. In

fact, their trip as outlined by Washington comprised more than two thousand miles, an ambitious venture for three young princes. No doubt Madame de Genlis, their forward-thinking tutor had prepared the boys for a journey such as this, making them strong by insisting that they walk in lead-soled shoes, sleep on the floor and experience other hardships. That itinerary led down through Staunton, Charleston, Abingdon, Knoxville, Nashville, Louisville, Lexington, Zanesville and then to Pittsburg. From there they traveled to Erie, Buffalo, Niagara Falls, through Rochester, down to Elmira and then back to Philadelphia. The three princes then traveled north to New York, Portland, Portsmouth, Boston, Providence and back to Philadelphia. Later, of their own accord, they would travel south to New Orleans and then to Cuba.

In this book, however, we will only hear about the princes' journey through New York, which began after Louis-Philippe and his brothers left Erie, traveling along Lake Erie and stopping at the Cattaraugus Reservation to visit the Seneca Indians. When they arrived, the chief was ill. Louis-Philippe had studied medicine among other things during his training with Madame de Genlis. He had studied under a surgeon and had served as an orderly in a hospital for a while. To relieve the ailing Seneca chief, Louis-Philippe bled him, apparently to great benefit because (to his brothers' amusement) Louis-Philippe was given the great honor that night of sleeping between two of the chief's most esteemed relatives, his grandmother and great aunt. The next day, the chief tried to take their dog.

Upon leaving, they traveled to Buffalo Creek, an Indian trading post, and then journeyed into Canada to view the spectacular Niagara Falls. Montpensier sketched the falls there. Montpensier would often make a sketch and create the full painting later, as was the case here at Niagara Falls. The painting was completed and dated years later in 1804 and hung in the Palais-Royal in Louis-Philippe's collections. Now it belongs to the Museum of the New York Historical Society and has been in their collection since 1950.

As the brothers left Niagara, they slogged through insect-ridden woods for days. By then they were soggy and ragged and wore torn clothing and boots riddled with many holes. Their money had been completely exhausted as well. There, in the swampland, they happened upon Alexander Baring, an English citizen who was engaged to Abby Willings's cousin. Upon seeing the princes in that sad condition, he asked if Niagara Falls had really been worth the trouble, and the princes affirmed that the sight of it most certainly was.

The four men traveled on, crossing the Genesee River by way of a rope ferry at Avon Springs and arriving at Dr. Timothy Hosmer's sanitarium. After being devoured by all manner of biting insects in the woods for weeks, the sanitarium seemed remarkable, offering therapeutic springs, a bathhouse and even a library. Their host, the surgeon Dr. Hosmer, was a bit of a dandy, sporting powdered hair dressed by his servant in a ponytail tied with a ribbon. His

deerskin breeches gleamed at the knees with silver buckles, and he was exceedingly clean.

A day after leaving the sanitarium, the men were met by Thomas Morris, Robert Morris's son. He was the agent for Genesee Country lands. Morris spoke perfect French and had brought a skilled French chef with him to the wilderness. Morris accommodated them in a well-appointed house and took the men fishing on Canandaigua Lake. They made the acquaintance of John Greig, a clerk in the land office, and the princes donned moccasins and went hunting duck and deer. Many years later, this same Scottish clerk would find himself a welcome guest of the king of the French.

The exiles traveled to Genesee Falls, which had been highly recommended by Morris. Though Montpensier sketched the falls, they seemed anticlimactic after the breathtaking beauty and power of the falls at Niagara. The men stayed in Brighton in a log house owned by Orringh Stone.

The men did see Rochester, but quite honestly, there was little there at that early date. Later, at the Paris Exhibition in 1840, Louis-Philippe saw an enormous plate glass window destined for Rochester and famously exclaimed, "What! Can it be that mud-hole is calling for any such thing?" It must be remembered that Rochester had few inhabitants until the Erie Canal opened in 1825, and when it did, the population of Rochester exploded overnight. In 1820, the population of the village of Rochester was a mere 1,502, but by 1850 it was a city of 36,403. Rochester became

known as a great milling town, but of course none of that was the case in 1797 when Louis-Philippe and his brothers passed through it. Back then, it had the appearance of a swamp equipped with a few shacks.

The group headed to Canandaigua, where they made the acquaintance of Captain Charles Williamson, land agent for the Pulteney estate. Williamson was also a builder on a large scale in wilderness territory, erecting cities along with entertainment facilities to accompany them.

By the time the men had arrived in Canandaigua, it was obvious that the horses were weary from the journey. As the men were headed to Geneva, Williamson suggested that the horses be sent through an easy overland passage. Williamson had a large, luxurious hotel in Geneva that still stands today, and it is believed that the men stayed there on July 13. From there the men traveled along Seneca Lake by foot and boat, at last arriving at present-day Elmira, then named Newtown. In Newtown, the men purchased a boat and floated down the Chemung and Susquehanna Rivers.

They came to Azilum on the Susquehanna River in Pennsylvania, which was a colony started by French expatriates to offer asylum to those fleeing the French Revolution. Louis-Philippe expert Morris Bishop does not believe that the men would have been welcomed at the colony. After all, Louis-Philippe's father, the so-called Citoyen Égalité, had voted to guillotine the king. Reputedly, however, Louis-Philippe was entertained there in La Grande

Maison, an eighty-four- by sixty-foot log cabin that some say was supposed to be the home of Marie Antoinette were she and her family to arrive there.

The men continued to Wilkes-Barre and, still apparently missing their mounts, rented horses to continue on to Philadelphia, ending this portion of their journey in America.

Louis-Philippe's exile in America was never actually a secret beyond the fact that the princes were traveling incognito; however, the journal that Louis-Philippe kept during his trip was only discovered in 1955 in the strongroom of Coutts's Bank in London when Madame Marguerite Castillan du Perron went through the Orléans family documents. While the journal does cover the bulk of their travels, it ends as the brothers enter New York.

## MILLARD FILLMORE: "THE AMERICAN LOUIS-PHILIPPE"

Millard Fillmore was born destitute on January 7 in 1800. A Unitarian and a member of the Whig party as vice president, he became thirteenth president of the United States from 1850 to 1853 after the death of President Zachary Taylor. Fillmore was nicknamed "the American Louis-Philippe." Apparently, he earned that nickname for his love of books and his elegance. However, the nickname does seem bizarre at the very least. It was Millard Fillmore

who signed the Fugitive Slave Act and appointed Daniel Webster as secretary of state. Soon after the Fugitive Slave Law was passed, Webster spoke in Syracuse during an abolitionist convention and incited the rage of abolitionists gathered, resulting in the famed Jerry Rescue.

Louis-Philippe, on the other hand, was the son of Louis-Philippe Joseph, who renamed himself Citoyen Égalité during the French Revolution. Citoyen Égalité raised his sons with a most liberal education, which included learning trades such as cabinetmaking and harvesting crops with the local peasants. When Louis-Philippe came to America, he was appalled with the institution of slavery. When Louis-Philippe visited George Washington at Mount Vernon, he spoke to Washington of the institution of slavery. Witnessing that the slaves would bow down low to whites at a distance, Louis-Philippe would shock them by bowing back. He found the condition of slaves deplorable and was much troubled by it. Louis-Philippe believed that one day there would be a horrible slave revolt.

Louis-Philippe was also not the picture of elegance that Fillmore purportedly was. When Louis-Philippe came to Philadelphia, society was quite excited to meet a real prince, but it was written by one woman who met him that he had "none of that commanding dignity, or even an ease of manner which is generally looked for." He was a penniless man at the time, living on a loan and known to have thrown a dinner party at which half the people were seated on his bed for lack of chairs. Even on the throne, he

was known for his miserliness and would have the burnt stubs of candle wax sold for money. He and his wife would go shopping together when he was king and take the bus home. In a final act of frugality, when mobs rushed the Tuileries, Louis-Philippe and his queen hailed a cab and made their way into exile.

I am uncertain how the nickname "the Louis-Philippe of America" fits Fillmore in any respect, as I am convinced that there were no two men more unalike. But the thing that Millard Fillmore is most famous for is the one thing that he never did. Millard Fillmore never put a bathtub in the White House.

## THE BATHTUB HOAX

The "Bathtub Hoax" is a remarkable story, for the tale of the bathtub remains self-perpetuating even today, long after H.L. Mencken, author of "A Neglected Anniversary" confessed to the hoax and then later confessed again. In fact, the story was meant as a joke rather than a hoax. It happened like this.

On December 28 in 1917, an article by H.L. Mencken called "A Neglected Anniversary" was published by the *Evening Mail* in New York. The story was about the history of the bathtub, and it was entirely invented. As Mencken would later write in his confession in the *Evening Mail*, "This article was a tissue of somewhat heavy absurdities, all of

them deliberate, and most of them obvious." In the article he alleged that the seventy-fifth anniversary of the bathtub had just passed by but, as he says, "Not a plumber fired a salute, or hung out a flag. Not a governor proclaimed a day of prayer. Not a newspaper called attention to the day." Truly, Mencken's opening was a bit theatric, but he went further, weaving a ridiculous tale. Mencken explained how a cotton and grain dealer by the name of Adam Thompson in the "squalid frontier town" of Cincinnati frequently traded in England and there acquired the English habit of bathing, which then took place in a bathtub little bigger than "a glorified dishpan." It was a difficult operation, requiring the assistance of a servant, and in 1835 it was said that Lord John Russell was the only man who maintained it as part of his daily regimen.

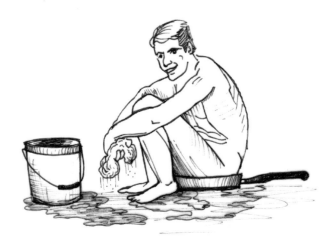

Now, Thompson, man of ingenuity that he was, imagined that bathing would be easier in a larger vessel with plumbing to supply the water so to not require a maid. Upon arriving home, he designed a tub of large size and attached a pump to his well to supply the water. The cold water was the simpler of the two water pipes. This water was pumped through piping to an attic tank, the pump being operated by six Negros. Then the line was fed by gravity down to the bathtub. The hot water had to be pumped through piping shaped like a coiled spring up the chimney to obtain proper heating. Hot and cold water ran into the seven-foot-long, four-foot-wide, 1,750-pound sheet lead soldered bathtub that stood above his reinforced floor.

On Christmas Day, Thompson displayed his bathtub to some gentlemen guests, and they all bathed in it, including a Frenchman. The following day, the story of the bathtub was covered in the local paper, and controversy raged. Some suggested that it was an English means of corrupting our democratic society, while others declared it a health hazard. The battle continued in other cities, with the Philadelphia Common Council nearly prohibiting bathing between November 1 and March 15. Boston banned bathing except for medical reasons.

Of course, the cost of a bathtub was prohibitive until John F. Simpson, a Brooklyn plumber, created a less costly tub of simple pine lined with zinc in 1847. By 1848, all New York City plumbers were qualified to install bathtubs, and by 1850 there were almost one thousand tubs in the city.

Though medical opposition had been strong in the early years of the bathtub, by 1849 Oliver Wendell Holmes pronounced his support of the bathtub to the American Medical Association at its Boston meeting. At that time, 55 percent of doctors in attendance believed that the bathtub was harmless to health and a full 20 percent believed that bathing was a hygienic habit.

Nonetheless, it was not until President Millard Fillmore advocated the bathtub that it actually gained its well-deserved recognition. While Fillmore was vice president, he viewed the bathtub on a stumping trip to Cincinnati. Fillmore was a guest at the home and bathed in the famed tub. He noticed no decline in health after his bath and became thereafter a notable proponent of the tub. After Taylor was assassinated and Fillmore was sworn into office in 1850, Fillmore gave his secretary of war, General Charles M. Conrad, the job of inviting bids for the construction of the first bathtub in the White House.

Some members of the public were shocked since previous presidents had had no such extravagance. The *New York Herald* even suggested that Fillmore fully intended to install a porphyry and alabaster bathtub that had been used by Louis-Philippe at Versailles. Of course, that was sheer nonsense, and Conrad awarded the contract to Harper and Gillespie, a Philadelphia engineering team that dutifully installed a cast-iron tub of appropriate size in 1851. It remained in use in the White House until Grover Cleveland replaced it with an enamel bathtub. By 1860, it

was known that all hotels in New York had a bathtub. Some even installed multiple tubs for the convenience of their guests. In 1862, General McClellan introduced bathing to the army.

Mencken concludes by wondering at the dearth of material previously available regarding the 1942 centennial of the bathtub and hoping that others would follow his lead and continue the research on this very important

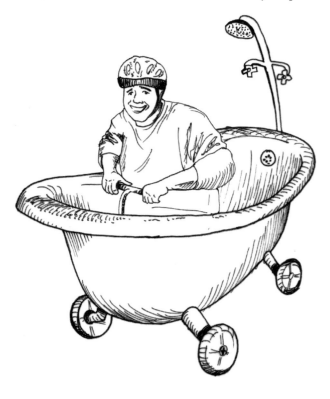

topic. Obviously, no one did research the matter, and though the article appears quite obviously tongue-in-cheek, many took it quite seriously and it began to be quoted. In time, the story, or quotes from it, began to appear everywhere; now, over ninety years later, the list of publications or institutions that have printed or presented this information as fact appears nearly endless. Never mind that the author of the hoax confessed twice that the article was entirely untrue.

The great hoax is still celebrated with pizzazz. In Moravia, close to Summerhill, where Millard Fillmore was born, there is an annual event called Fillmore Days during July. One of the more spectacular activities is a race involving bathtubs on wheels that speed down Main Street, more evidence that Henry Mencken's story will never be forgotten.

## THEODORE ROOSEVELT TAKING A BATH

William McKinley and Theodore Roosevelt handily won the 1900 election after some vigorous campaigning. However, on September 6, 1901, McKinley was shot in the chest and abdomen in Buffalo during the Pan-American Exposition by Leon Czolgosz, who hid a revolver in a handkerchief. Roosevelt visited McKinley on September 10, and the president seemed to be improving. For the sake of appearances, Roosevelt was asked to leave to

restore faith in the president's health, and so Theodore Roosevelt left for the Adirondacks. There, he, his wife Edith and his children decided to climb New York's tallest mountain, Mount Marcy. However, during the hike, McKinley began to decline physically, and Roosevelt was recalled when a man climbed Mount Marcy to deliver the news to him. A second telegraph arrived soon thereafter announcing that the president was dying, and Roosevelt traveled by buckboard to the train station, and then by train, a grueling journey as the train was involved in a small collision; nonetheless, Roosevelt arrived at last in Buffalo. There he borrowed clothes from Ansley Wilcox, a friend, and later Roosevelt convinced the cabinet to hold the inauguration ceremony at the Wilcox Mansion. There were only a handful present at the ceremony.

Naturally, the historic events were recorded by all the papers. Unfortunately for President Roosevelt, one reporter made a one-letter typographical error and reported Theodore Roosevelt as taking a bath rather than an oath. Despite the seriousness of the occasion, the error struck the funny bones of some citizens. Postcards were manufactured featuring a line drawing of a large claw-footed bathtub with the head and shoulders of a bespectacled Teddy Roosevelt popping over the top. Below on the face of the cards, they read: "Teddy Roosevelt taking a bath."

## THE BOVINE BRIDGE

Just outside of Vernon, train tracks were laid across farmland. Over the tracks, a metal overpass was built there in the middle of nowhere, and though the train tracks have vanished with time, the overpass still remains in its mysterious location.

At the time that the tracks were installed, they sliced a farm in two, and the overpass was constructed so that the cows could move freely over the third rail from one pasture to another.

## THE UNDERTAKER'S EXPANDING TABLE

Thanksgiving is such a marvelous holiday because we are able to welcome family into our home, and on that one day of the year, we can often expect to dine together. It is a tradition that we must all share the meal, so we pull apart our dining room tables and add an additional leaf or two so everyone will have a place. The expandable table was invented by Seth Genung of Waterloo, New York. He worked as a furniture maker and an undertaker. His son, Charles A. Genung, invented the method of modern embalming still used today.

## The Formal Mill Fire

On New Year's Eve 1891 in Waterloo, New York, a four-story brick building filled with grain called the Railroad Mill caught fire. The building was located on the east side of Washington Street and had been newly refitted. The grain burst into flames, and the fire department was called. However, as it was New Year's Eve, many of the men were attending a ball; when duty calls, firemen answer the summons, and so the firemen came to fight the mighty conflagration dressed in their tuxedos and top hats. The men fought bravely, but the flames rose high in the night, and when it was finally extinguished, the damage to the building, machinery and loss of goods was estimated to exceed $45,000. The fire was immortalized in a painting by a local, which today hangs in Waterloo's Terwilliger Museum.

## THE EIGHTH WONDER OF THE WORLD

In Hanover Square in Syracuse, there is a stately white marble building that the locals claim once held the world's largest sheet of glass at the time as one of its windows, according to regional folklorist Dr. Daniel Ward. The glass is said to have been brought from New York City on a canalboat to Syracuse. It was then known as the eighth wonder of the world. On the edifice is carved the address One Hanover Square, though its current address is 120 East Genesee Street, and two dates are carved in the top corners of the building. On the left it reads 1884, and on the right, 1896. Both appear to be parts of the original façade, but the building is said to have been built in 1896. The building is currently known as the Flagship Securities Building. The large sheet of glass has since been removed, and more modern windows have replaced it. It now takes several sections to fill the space that once held a single sheet of glass. One presumes that the window was replaced in the name of energy efficiency. The building was designed by architect Albert L. Brockway and is known to be the first steel-framed building constructed in downtown Syracuse. Hanover Square was the heart of the original commercial center of Syracuse, not far from the Erie Canal. The square and surrounding streets contain a variety of examples of magnificent historical architecture from styles ranging from the Federal and Second Empire to Art Deco.

## MATILDA JOSLYN GAGE: FORGOTTEN SUFFRAGIST

Though the names Elizabeth Cady Stanton and Susan B. Anthony recall images of the franchise campaign for women, for most people the name Matilda Joslyn Gage hardly sounds familiar at all. However, Gage was historically a prominent proponent of the vote for women, a spokeswoman for the clear separation of church and state and a supporter of freedom for all. Her home in Fayetteville, along with her childhood home in Cicero, operated as part of the Underground Railroad system. Aside from her prominent political role historically, she was also the mother-in-law of L. Frank Baum, the beloved author of *The Wonderful Wizard of Oz*. Though those around her maintained their places in our historical memory, Matilda Joslyn Gage did not—that is, until Dr. Sally Roesch Wagner began her pioneering work in women's studies at the University of California in Santa Cruz. She received her PhD in 1978 and cofounded one of America's first women's studies programs at California State University in Sacramento. During the course of her work, Wagner became intrigued by the story of Gage and started a foundation to restore Gage's rightful place in history.

Gage's house itself stands in Fayetteville, New York. Its Greek Revival façade faces Route 5, a major road through the area. Though many passed the home, few understood the historical importance of that stately building until Wagner began her campaign. At the time of purchase, the home had been allowed to deteriorate considerably, and there was

substantial renovation work that needed to be completed before the home could be opened as a museum and library of Gage's work. The Matilda Joslyn Gage Foundation hoped to reconstruct the property as it was in the day when Gage resided there, and an archaeological dig was conducted on the property's rather modest lawn, revealing, in addition to various artifacts, the foundation of an old woodshed that will be recreated to become the welcome center, as well as kitchen and restroom facility. The group was fortunate in the fact that L. Frank Baum, who lived with his mother-in-law for a time at the house, was an amateur photographer and did in fact photograph the home as it was in 1887. Baum and Maud, Gage's youngest daughter, were married in the parlor of the house. The pictures still exist, and the group is using them to recreate the exterior and the interior down to the furnishings and the taxidermied owl that used to be displayed there.

Matilda Joslyn was born on March 24, 1826, in Cicero, the daughter of Dr. Hezekiah Joslyn, an active abolitionist and one of the founders of the Liberty Party. Young Matilda learned the importance of freedom and equality for all in her childhood home.

In 1845, Matilda married Henry Hill Gage, and their marriage yielded four surviving children, the youngest of whom was Maud, a vivacious girl and a favorite of Matilda's. The family, in time, purchased the home in Fayetteville, and that home, like Matilda's childhood residence, was used to defy the law, hiding runaway slaves in their journey north to freedom.

Matilda also became involved in 1852 in the women's rights movement and was a speaker at the national convention held in Syracuse that year, the same convention at which Susan B. Anthony entered the women's rights movement. Gage remained a staunch supporter of women's rights throughout her life, founding the National Woman's Suffrage Association along with Susan B. Anthony and Elizabeth Cady Stanton.

Gage, like other women, boldly attempted to vote at a time when voting was illegal for women, but unlike others, she was the only one who came to Susan B. Anthony's aid when Anthony was arrested and tried for voting. Gage joined her in publicizing the trial, sat with her during it and subsequently analyzed the case for the *Albany Law Journal*.

In what appeared to be a success, the New York Woman's Suffrage Association was able to obtain the right for women to vote and hold office in school elections in 1880, and Gage held meetings in her own home to produce an all-female slate of candidates for the offices. Gage herself voted in the election, but in 1893 Gage was served with a supreme writ for voting. Gage was used as an example in a test of the constitutionality of women voting for school commissioners (a state office), and in the end Gage lost her case and women were once again deprived of voting rights in elections involving New York state or federal officials.

Strikingly, it was Dr. Sally Roesch Wagner, a scholar living in California, who became committed to rediscovering Matilda Joslyn Gage and reintroducing her to the American public. In the 1970s, Dr. Wagner was teaching an introductory class

on women's studies and wanted additional historical content, but at the time she had not yet developed a fascination with the women's suffrage movement. One of her friends, also a scholar, was working on a paper about the 1890 South Dakota women's suffrage campaign in Aberdeen. She came across some incredible information on an important suffragist named Matilda Gage who had some connection with Aberdeen, South Dakota. She asked Sally if she had ever heard of Gage since Wagner was from Aberdeen. Though Wagner hadn't, she did remember that her mother had a friend named Matilda Gage and wondered if she were any relation. Wagner asked her mother, who explained that her friend, Matilda Jewell Gage was indeed the granddaughter and namesake of Matilda Joslyn Gage. Wagner asked her mother if her friend knew about her grandmother's work in the women's rights movement, and her mother said that she was certain she did since Matilda possessed her grandmother's papers. Additionally, when Sally had been quite young, Matilda Gage and Sally's mother performed a skit for the Dakota Territorial Pioneers in which Sally's mother played Susan B. Anthony and Matilda Jewel Gage played Matilda Joslyn Gage.

The next time Sally Wagner went home, in the summer of 1973, she arranged to meet Matilda Gage, hoping to collect a few remembrances of Matilda Joslyn Gage. However, when she arrived at her home, she discovered that Matilda had brought out volumes of her grandmother's correspondence, as well as old photos, scrapbooks and other documentation. Wagner was floored when she read Gage's letters. It became

immediately apparent that Gage and Susan B. Anthony had not only worked closely together, but also that issues had arisen between them. She was immediately intrigued.

When Wagner finished her master's degree in psychology, she applied to the History of Consciousness Program at the University of California–Santa Cruz, where she could concentrate on her interdisciplinary work in the area of women's studies. There were no women's studies doctoral programs in the country at the time. She did biographical work on Matilda Joslyn Gage and received one of the first doctorates awarded for work on women's studies in the country.

Matilda Joslyn Gage was L. Frank Baum's mother-in-law, and she would spend each winter living with the Baums after her husband died in 1884. When they lived in South Dakota, she stayed with them there as well.

Wagner took a research trip on Gage to Syracuse in 1976. Barbara Rivette—historian for the town of Manlius and village of Fayetteville and editor of the local paper, the *Eagle Bulletin*—took a photo of Wagner standing on the steps of Gage's old house on Route 5 in Fayetteville. At the time, Wagner thought to herself that the house should be open to the public, but she had no inkling then that she would be the one to work toward that end. She kept watching the house, though, which had become rental property. In the meantime, Wagner would come back to Syracuse every year and would lecture on Gage at a variety of venues including Le Moyne College, Syracuse University and the Onondaga Historical Association.

In 1997, Wagner came to Syracuse as the Jeannette K. Watson Distinguished Visiting Professor in Women's Studies for six weeks and held some meetings to discover if there was any interest in saving the Gage house. There was, and so Wagner got in touch with the owner of the property. The owner of the house was a teacher who purchased it as rental property and knew nothing of its historical value nor did she know of Gage. The property had been divided into three apartments, but the basic structure had not changed. Wagner decided that she might be interested in moving to Fayetteville to try to do something with the house.

In 1998, Seneca Falls was celebrating the 150th anniversary of the first National Women's Rights Convention. Wagner organized exhibits on Gage and the Haudenosaunee (Iroquois) influence on women's rights and worked unofficially as a visiting scholar at Seneca Falls working on curriculum development, lecturing and performing. She stayed in the ranger station next to Elizabeth Cady Stanton's house. There was noticeable interest in Gage from people who went through the exhibits. Wagner got in touch with the owner of Gage's house and said that she was ready to move to the Gage house and asked the owner to let her know when there was an apartment available.

In winter of 1999, the owner called. There was an apartment available, and Wagner sold her five-bedroom home in South Dakota in which she lived alone and moved into a one-bedroom apartment in Matilda Joslyn Gage's old home. She drove out with her car and a U-Haul trailer,

bringing little more than her books and research materials. At various times, Wagner lived in each one of the apartments before the Gage Foundation closed the house for restoration. She began to hold meetings letting people know about Gage. She gathered people around her who shared her interest in the suffragist and incorporated.

Mary Anne Krupsak—who had been elected the country's first lieutenant governor in 1974 and is now secretary on the Gage Foundation Board of Directors—helped get them through the incorporation process, and the Gage Foundation was incorporated in 2000 as a nonprofit organization. It received its tax-exempt status in 2001, and the following year the foundation was able to purchase Gage's home for $130,000. The money was raised nationally with descendants of Matilda Joslyn Gage contributing substantially to its purchase. Since then, the foundation has begun raising money to offer public programming and to restore the property, which had suffered neglect during its time as a rental property. It has held two national Gage conferences in Fayetteville and a reenactment of the 1852 suffrage convention and conducts programs and tours for over four thousand people a year. In 2008, the International Wizard of Oz Club moved its convention to Fayetteville so it could join with the Gage Foundation's Wonderful Weekend of Oz.

The Gage Foundation has raised money through grants and donations to restore the Gage home. The house will look much as it did in the photos of the parlor and exterior of the home taken by Baum in 1887. The foundation hopes

to regain much of the parlor furniture from descendants of Gage, and a stuffed owl has been contributed by a supporter to replace the one shown in Baum's parlor photograph that is no longer possessed by the family. The rest of the house will be restored as areas in which aspects of Gage's life will be presented. Wagner says that this will be a house of ideas, not a place where you can see where Gage slept and ate. She also sees it as a house of dialogue where people can come to talk about these ideas. The foundation is interested in showing what Gage stood for, rather than how she might have lived beyond the parlor.

When completed, the home will feature a series of rooms that each represent a different aspect of Gage's life: the Underground Railroad Room, the Family Parlor or Oz Room (Gage encouraged Baum to write his stories and her ideas influenced them.), the Religious Freedom Room, the Haudenosaunee Room (Gage was adopted into the Wolf Clan of the Mohawk tribe.), the Local History Room, the Dakota Room or Gift Shop and the Matilda Joslyn Gage Research Library. Wagner hopes that the building will be completed about June 2010. Descendants of Gage are on the advisory committee and regularly contribute their thoughts and ideas on the direction of the project. The Gage Foundation is interested in both volunteers and contributors to continue forward with its dream. You may visit its website at www.matildajoslyngage.org.

## DOGGIE, DOGGIE, WHERE'S YOUR BONE?

Curator Tanya Warren at the National Memorial Day Museum found a copy of a document among her records that describes the following. In the summer of 1903 on the Young Farm in the town of Ledyard located in Cayuga County, A.B. Comstock and G.A. Ward of Serwood, New York, began uncovering a grave. They found a remarkable skeleton that was nearly complete, but the men soon had to flee a sudden and severe thunderstorm. They ran nearly an eighth of a mile and took cover in Young's barn, where they were forced to wait out the storm for two hours. After

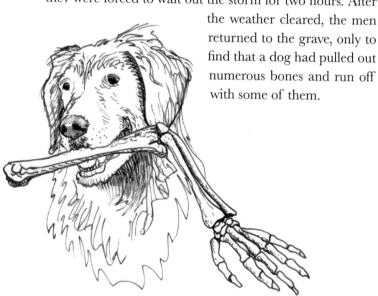

the weather cleared, the men returned to the grave, only to find that a dog had pulled out numerous bones and run off with some of them.

## GREENE SMITH AND THE BIRD HOUSE

The name Greene Smith is only familiar to a few people today, unlike the name of Greene's father, Gerrit Smith, who is remembered by many for his great philanthropy, his work as an abolitionist and his work on the Underground Railroad. Greene Smith and his sister, Elizabeth Miller Smith, were the only two of Gerrit Smith's children who lived to adulthood. Greene developed an extraordinary interest in birds early in life and designed what became known as "the Bird House," which was constructed on the Gerrit Smith estate near the creek in Peterboro while Greene was a teen. His father probably funded the project.

The Bird House was remarkable in its design, and its simple hemlock bark façade belied its luxurious interior. Gerrit Smith was a very wealthy man, but he also had a reputation as demanding that his family live frugally, so in a sense, the Bird House seems to deviate from that path of simple living. The Bird House is no longer in existence today, but descriptions of it remain. In their youth, Donna Burdick (now the historian for the town of Smithfield) and her sister Beth Spokowski (now the organizer of the Peterboro Civil War Weekend and the person who spearheaded the effort to develop Peterboro as a national and state historic site) used to crawl in the side window of the dilapidated Bird House, cross over the collapsing floorboards and make their way through its vast interior. Donna took the time as a young girl to draw a floor plan of the Bird House and kept it in her

journal. The two girls would inevitably go home to beg their parents to buy the property and renovate it, sparking their imaginations as it did, but no such renovation happened; ultimately, the Bird House was lost to time.

It was a peculiar design that featured windows on the outside, a corridor running around the edges and an interior set of widows. This Bird House was not an aviary, for it did not house live birds. In fact, it was Greene's custom to shoot birds and to use his taxidermy expertise to prepare them. Some suggest that Greene used the Bird House's marble sink to do his taxidermy work. That sink is preserved in the ladies' restroom at the museum in Peterboro. However, Donna Burdick suggests that it was more likely that Greene did his taxidermy preparations in the basement. Then the specimens were mounted on stands and pedestals in the numerous cases displayed in the Bird House. In addition to his own work, Greene also purchased stuffed birds to display, and his collection grew very substantial. In the end, his collection is known to have included over two thousand birds, nests and egg specimens, and the collection was considered invaluable. Perhaps most remarkable was his hummingbird collection that was valued at $8,000 at the time of his death. This was Greene Smith's private collection, his own personal museum.

The building itself was remarkable for a structure in the small village of Peterboro in 1863. The exterior of the three-story Bird House was rustically simple; the interior included a mahogany staircase that led to the open atrium

and almost all of the building could be seen from the top of the stairs. A birch-bark canoe and a magnificent skiff were suspended from the ceiling of the Bird House. On the second floor were Greene's hunting and fishing supplies, including guns, fishing rods and camping gear, as well as a display of trophies. The building featured early climate control—that is, central heating—to provide a more stable environment for the specimens. The building contained stained-glass windows, as well as polished birch paneling.

Greene himself was a sportsman and active in procuring conservation sites designated for hunting and fishing in New York State. He was also a breeder of hunting dogs. But above all, he is remembered for his birds. Greene Smith lectured at Cornell University and was admired as a skilled taxidermist.

Greene died at a mere thirty-eight years of age from tuberculosis. Before he died, he moved into the Bird House, where he could finish cataloguing his birds, and was visited by friends there. Greene offered his valuable collection to the Central Park Museum in New York City, but the administration refused the offer, not understanding the value or vastness of the collection. Later, the museum wrote Greene—it had reversed its position and had decided to accept the collection; however, Greene wrote back noting that the offer no longer stood.

His funeral was held in the Bird House for friends and relatives, and others were offered space on the expansive lawn outside. At the time of the funeral, a grand piano occupied

a space in the Bird House. He left a significant part of his collection to Cornell, Harvard and Colgate Universities, and these gifts became the cores for the ornithological collections on those campuses. Greene Smith's catalogue of specimens from his Bird House may be seen online today, methodically recorded. A small group of interested people around the Peterboro area has begun research on Greene Smith's life, collection and Bird House.

## UNCLE SAM: DENIZEN OF TROY, NEW YORK

Everyone is familiar with Uncle Sam, the tall, bearded mascot of the United States, clothed in red, white and blue with his unique top hat. Few, however, recall Uncle Sam's humble origin in Troy, New York.

It is believed that Uncle Sam was originally manifested in the very person of Samuel Wilson. Wilson was born in Arlington, Massachusetts, in 1766, but as a child he lived in Mason, New Hampshire. In 1789, Samuel Wilson and his brother Ebenezer walked to Troy, New York, and by the War of 1812, Samuel Wilson worked in the slaughtering and meatpacking business that sold meat to the U.S. Army. Wilson was a beef and pork inspector, and the barrels that left his meatpacking operation were stamped "U.S." Apparently, people at the slaughter and packing operations were uncertain as to what the initials signified, so someone, perhaps lightheartedly, suggested that they referred to

"Uncle Sam Wilson." So many barrels marked "U.S." were sent out that people began to comment on Uncle Sam's great wealth. Eventually, Uncle Sam came to signify the United States by the 1820s, but he did not gain great popularity until after the Civil War. Samuel Wilson is buried in the Oakwood Cemetery in Troy, New York.

Before the Civil War, the United States was symbolized by another mascot, Brother Jonathan, now largely forgotten. There are, in fact, a number of great physical similarities between our current image of Uncle Sam and the historical Brother Jonathan. In fact, many people unfamiliar with Brother Jonathan readily misidentify him as Uncle Sam. Brother Jonathan is often seen in the red, white and blue striped pants, a tailcoat and a top hat, but unlike the gray, bearded Uncle Sam, Brother Jonathan is younger, with darker hair and cleanshaven and was often shown with a feather in his hat. Needless to say, Samuel Wilson did not wear Uncle Sam's outlandish costume. Nor did he sport a goatee. Wilson was a cleanshaven man. Uncle Sam's appearance developed through his portrayal by political cartoonists such as Thomas Nast. Nast himself was a German immigrant who lived in New York City and did much to develop our current image of Uncle Sam. A Nast cartoon also gave us the elephant and the donkey as the symbols of the Republican and Democratic Parties, respectively.

Originally, it is believed that the name "Brother Jonathan" was a derisive term used by British Loyalists to describe

Patriots. George Washington is thought to have said, "We must consult Brother Jonathan when faced with a difficult decision." Brother Jonathan represented the United States when the states were more independent entities. After the Civil War, Uncle Sam came to represent the states as a unified group. Just as before the Civil War we were "these United States"; after it we were "the United States."

## THE PUBLIC UNIVERSAL FRIEND

Jemima Wilkinson was born in the ordinary way to parents in the town of Cumberlain, in the county of Providence, Rhode Island, about 1758. Her father was a farmer and her mother a Quaker. Jemima lived in a busy household and was the eighth of twelve children born to the couple. She seemed a lovely girl, attractive and intelligent, and she had an average education for a girl her age. She particularly loved to read and was fond of poetry, romance, news and various forms of light reading. Other than that, she wasn't extraordinary except for the fact that she seemed to rule the household and seemed a bit domineering. She enjoyed wearing flattering clothing and attended church regularly.

When Jemima was around sixteen years old, a new sect formed nearby that believed that a person must seek personal guidance from heaven rather than through the organized church. Jemima Wilkinson began to attend the meetings held by this group, though she did not call herself

one of them. Her demeanor changed rapidly from that of a frivolous young girl to that of a serious-minded young woman. She gave up her old pleasure reading in favor of constant study of the Bible. She became solitary rather than the social girl she had been. Her mood grew gloomier until the summer of 1776, when she began to complain about her health. She appeared pale and sickly, but the physician who attended her explained to the family that Jemima suffered from no physical ailment—the episode was a result of her mental state. He could offer no help in her recovery.

As fall came, Jemima grew increasingly ill and remained completely bedridden. Her condition had become so serious that family and friends stood by on nightly watches. She began to describe scenes of heaven and angelic visitors that others could not perceive. In October, Jemima fell into a coma with much-reduced respiration and pulse rates, leaving her family to believe that she would not survive. Her condition remained as such for at least thirty-six hours until midnight on the second day, when she suddenly rose up, as if from a deep sleep. She appeared refreshed, though still pale and thin. She immediately demanded her clothing in a tone of great authority. Having dressed herself, she explained that Jemima had passed on, into the heavenly world of angels, but her body had been reanimated by another spirit to serve as God's oracle to the people of the world.

Her relatives and friends were shocked and disturbed by these strange claims and the change in Jemima, but she refused to alter her story to her dying day. She also

refused to retain her old name of Jemima Wilkinson and instead referred to herself as the Universal Friend. As such, she became the first America-born woman to found a religious movement.

On the very next Sunday, the Friend attended church. After the service was completed, she stood beneath a nearby tree and began preaching to all who gathered. People were impressed by the young woman's spiritual knowledge and force of character. She began giving spiritual speeches regularly and soon amassed a large number of disciples. She preached in Rhode Island, Connecticut and Massachusetts at various locations. Her belief system embraced the basic principles of Christian faith but discarded the rituals of common practice. The Friend stressed the importance of virtues such as sobriety, temperance, chastity and kindness. She continued to preach in those regions for about six years; then she began to visit Pennsylvania, preaching and adding to her following. With time, a vision of establishing a home for her sect arose.

In 1786, Ezekiel Sherman journeyed with two Indian traders to Kanandesaga to find a suitable location for a religious settlement. However, he reported back that it would be futile to try to form a community in the Genesee Country due to the Indian presence. Still, a second exploration party was sent and reported back that the areas surrounding Seneca Lake were extraordinarily rich, and the religious society decided to settle in that region. The exact location was to be determined by an advance team.

In June 1788, a group of men left Schenectady to find a proper settlement location. By August of that year, they had found a fine locale for their New Jerusalem by a waterfall on the Seneca. They cleared land and sowed wheat, though it was practically fall, and they applied to Governor De Witt Clinton for a land grant. By spring of the following year, followers began to arrive from Connecticut, Rhode Island and Pennsylvania. Though the Friend had planned to come in 1789, she remained at her farm in Rhode Island attending to society business and did not actually arrive until the following year, 1790. Apparently, the Friend attempted to come in 1789, but there was an accident at Bushkill Creek after a heavy rain, and the Friend, among others, nearly drowned on the journey. She was forced to return to Rhode Island to recuperate.

Settlement was difficult in 1789. Though the group's members enjoyed a prime location on Seneca Lake, wild animals ate their crops and they suffered greatly, with some settlers surviving on a diet of milk and boiled nettles. Later, they were able to plant corn and erect a sawmill and later a gristmill, which was the first in the area and drew farmers from as far as seventy miles away to do their milling. During the construction of the mill, a millstone was dropped from the upper story. No one knew how they would get it back up, and everyone except Richard Smith left for a time. When they returned an hour later, he had single-handedly, using leverage cleverly, replaced the millstone, prompting the story that Friend Richard carried the millstone upstairs in his leather apron.

By 1790, the community of Friends consisted of 260 settlers, and they constructed a log meetinghouse in which the Friend could preach. By this time, the Friend was about thirty-two years old and called herself the "Public Universal Friend." Pronouns were never used to refer to the Friend. She was said to have treated others with great kindness and generosity, and even the Indians felt friendly toward her.

The Friend preached at the treaty at Newtown in 1791, at which five hundred Seneca were assembled, and the Friend met Red Jacket, Corn Planter, Good Peter, Reverend Samuel Kirkland and other notable figures. Later, at the treaty in 1794 in Canandaigua, the Friend preached to Indian and settlers alike and was given the name "Squaw Shinnewawna gis taw, ge" or "A Great Woman Preacher."

About 1788, the religious group was invited by Governor Clinton to purchase land at a sale in Albany. The group bought 14,040 acres on the west bank of Seneca Lake as tenants in common, and the deed was signed by Clinton in 1792. Later, grants made based on the old preemption line became void, and legal battles ensued, creating ill will and financial hardship in some cases. The group was embroiled in years of litigation. As time went on, some ex-members of the society began to speak out against the Friend, and on several occasions warrants were issued for her arrest, though she skillfully evaded capture. In the end, charges were dropped against the Friend. She died at age sixty-one, but the group did not survive her passing well. Her portrait and some papers and artifacts of the Friend remain at the

Oliver House Museum in Penn Yan. She helped pioneer and populate what became Yates County.

## THE GREAT DISAPPOINTMENT

Once there was a man who lived in Low Hampton, New York, named William Miller. Originally, Miller had been a Baptist; then, during a period when he was exposed to deistic beliefs in Poultney, Vermont, where he lived awhile, he forsook his Baptist faith and adopted deism after reading Voltaire, Hume, Paine and other noteworthy deists. He served in the War of 1812 and, following that, returned to Poultney, only to soon after move his family back to Low Hampton to begin farming.

Miller began to contemplate mortality after his father and sister died and in view of all that he had witnessed during the war. He began to reaffirm his previous Baptist faith and resumed attending church. The minister was often absent, and one day when Miller was asked to read the sermon, he became overcome with emotion as he saw Christ in a new light as a being of extensive compassion.

Miller's deist friends confronted him on his change of faith, and Miller began to study the Bible to understand and justify what he saw as contradictions. He would study a passage until he believed that he understood it fully, and he came to believe that the Bible prophesied Christ's second coming. Miller was particularly convinced by Daniel 8:14:

"Unto two thousand and three hundred days; then shall the sanctuary be cleansed." He interpreted this passage using the day-year principle that suggested that a day was equal to a calendar year, or 365 days. Miller came to believe that the period began in 457 BC and therefore calculated that Christ would return in the year 1843.

Miller came to this conclusion in the year 1818. Still, Miller was a careful man and did not announce his finding until 1823, after years of further study.

Miller began to lecture on the subject in August 1833 in Dresden. He published sixteen articles in the *Vermont Telegraph* on the subject and later published a sixty-four-page tract entitled "Evidence from Scripture and History of the Second Coming of Christ, about the Year 1843: Exhibited in a Course of Lectures."

By 1840, Millerism, as the belief in the near future Second Advent was known, became a strong national religious movement, and the number of believers were estimated to be between 50,000 and 500,000. Miller stated that "Jesus Christ will come again to this earth, cleanse, purify, and take possession of the same, with all the saints, sometime between March 21, 1843, and March 21, 1844."

Passionate followers began to anticipate the great event. There were followers who sold all their possessions and on March 21, 1844, some were said to ascend hilltops to gain proximity to heaven, wearing white robes to await the Second Coming of Christ and vindication. But March 21 came and went without event. Miller realized his error and recalculated using the Karaite Jewish calendar rather than the Rabbinic one. Now, the great return was expected to fall on April 18, 1844. Once again Christ failed to make his grand return. Following the second miscalculation, it was declared in August 1844 that Christ would return on the tenth day of the seventh month of 1844, which was determined to be October 22, 1844. Once again the Millerites awaited, but on the morning of October 23, it was apparent that Christ had not appeared. The Millerites wept copiously, and the day became known as "the Great Disappointment." Most left the sect, though Miller refused to abandon his belief that Christ would return soon. Many Millerites were verbally abused, and satires of Millerites abounded. Following the Great Disappointment, Millerites were greeted by

jeers of "Have you not gone up?" and "Have you a ticket to go up?"

In other instances, violence erupted. A Millerite church was burned in Ithaca, and two others in New York State were vandalized. Some continued to believe that Christ was coming and joined the Adventist church that Miller helped found, but that sect did not give a specific date as to when Christ might be returning.

## CEPHAS BENNETT AND THE BURMESE BIBLE

The Tabernacle Baptist Church is located at 13 Clark Place in Utica, New York. It is a stately old building formed of large stone blocks. The church looks like it has stood there forever, and in fact, behind this traditional exterior stands a long and unusual history. This church since the nineteenth century has held strong missionary ties to Burma. At that time, it was known as the Second Baptist Church. This story begins with a layman printer named Cephas Bennett.

On March 30, 1804, Cephas Bennett was born in Homer, New York. His father was a home missionary named Alfred Bennett who would leave for weeks on end ministering in the far wildernesses of New York State. At the age of thirteen, Cephas went to serve a seven-year apprenticeship with an experienced printer, and in time Cephas became the overseer of the issue of the Baptist

registry in Utica. Cephas wished to print the Burmese Bible in America.

Back in 1813, Adoniram Judson had gone to Burma as a missionary. Judson had set about translating the Bible into Burmese. However, he was forced to write to the United States for a printer when the existing printer could no longer be used, and ministry officials decided that young Bennett would print the Burmese bible in Burma. Cephas Bennett was appointed missionary in 1828 and set sail in 1829 with his wife and daughters Elsina and Mary for Calcutta, arriving in Maulmain in 1830, carrying with him his printing press. The printing of the Bible began soon after his arrival on Burmese soil.

In addition to printing, Bennett and his wife organized some schools. Apparently, their work was quite commendable because the Burmese government requested that they start the first English school, which they did. On a brief trip home in 1841, Cephas Bennett was ordained at the Second Baptist Church. He spent the rest of his life serving as a missionary in Burma.

The Tabernacle Baptist Church had connections to Burma for about one hundred years, but after that when the missionaries died off, the church began to forget its Burmese ties until one Sunday in the year 1999 when the first Karen Burmese family arrived at the sanctuary. The Karens are an ethnic group of about seven million that inhabit Southeast Asia, primarily in Thailand and Burma (now Myanmar). They had fled persecution

in Myanmar, arriving at the doors of the Tabernacle Baptist Church seeking the familiarity of the Christian faith they had practiced in the far reaches of Myanmar. The church was responsive to the physical and spiritual needs of their new neighbors, displaced from the other side of the world. The refugees were arriving in Utica, a refugee repatriation area. Refugees leave their country as they are able on short notice, arriving with only a single suitcase, and are responsible to repay the plane ticket for their transport here. Many had been living in poor conditions or had faced rape or other violence in their homeland at the hand of members of the military government. All refugees arrive with little or no money and possessions.

The Tabernacle Baptist Church embraced their new congregation members and helped supply some of their simple physical needs. As the church began receiving more and more Karen refugees, they rediscovered their own historical Burmese connection, the work of Cephas Bennett.

Today the church serves perhaps six hundred Burmese refugees. Services are held in both English and the Karen language at the church. Perhaps one-third of the three hundred parishioners seen on a typical Sunday there are Karen. They have become a strong part of the church and the surrounding community. In a way, they have come home to the very church that first brought the Christian faith to their homeland half a world away.

## RECIPE FROM THE DAWN OF TIME

Everyone knows that old recipes that have been passed down through the generations have withstood the test of time. Who, after all, would willingly toss grandma's old culinary secrets? In a version of the Iroquois creation story that Seneca Indian Jesse Cornplanter tells, the characters stop to cook an ancient form of corn chowder. You know the old adage that a soup grows better as it ages. This is, indeed, a time-tested recipe, reputedly almost as old as the earth itself. I have rearranged it to fit modern recipe format:

> *Ingredients:*
> *1½ quarts of sifted hardwood ashes*
> *¾ kettle of water*
> *2½ quarts of shelled white corn*
> *meat*
> *½ quart of colored parboiled beans*
>
> *Preparation:*
> *Add ashes to boiling water. Boil for five minutes, then add the corn. Boil the corn until it turns red and the hulls are loose, about an hour and a half, stirring occasionally so it does not stick. Remove from heat and rinse only briefly in a hulling basket. Boil again until the corn is soft and the hull can be removed. Rinse again until the water runs clear. Cook with meat and parboiled beans two to three hours.*

## THE HEAD IN THE BOX

Tanya Warren is the first curator that the National
Memorial Day Museum has had since its founding in the
year 1876. She takes her job seriously and engages in the
strenuous work of going through boxed and stored portions
of the collections belonging to the Waterloo Historical
Society Archives. During her organizational work, she was
stunned to recently discover a human skull rolling around
a box, the dirt still clinging to the ancient bone. The skull
was accompanied by a photograph of two well-dressed
men, one of them holding a skull and looking down at it
pensively. The men were Herman Brehm, former president
of the Waterloo Historical Society, and J. Willard Huff. The
photograph was labeled "Kashong Point, 1948." Kashong
Point was a burial site of Native Americans and, Tanya said,
also of a few early settlers. Another photograph showed a
human skeleton being exhumed.

Tanya immediately became concerned that the skull that
she had discovered in the museum's collection might be
the skull of a Native American. According to NAGPRA
(Native American Graves Protection and Repatriation
Act), anyone in possession of known burial implements or
bodies of Native Americans must return them to the tribe
of origin. Kashong Point is on Seneca Lake, and the local
tribe is the Cayuga Indians, a tribe of the Iroquois. Tanya
notified them of the skull and also notified the New York
State Museum in Albany.

Lisa Anderson, a forensic anthropologist from the New York State Museum in Albany, came to the National Memorial Day Museum with a computer equipped with sophisticated forensic software and some measuring devices; however even without the software, she realized that the skull was not the same skull displayed in the photographs. The remains in the photographs were those of a Native American male, and the petite skull in Tanya's box was that of a white woman. Anderson took a variety of measurements of the skull and entered the data into the computer. Soon it was discovered that the skull belonged to a white woman of European ancestry. The woman was young, somewhere between eighteen and twenty-four years

of age, and the skull was dated from the period between 1780 and 1820. Though some teeth were missing from the skull, those that were still there were in excellent condition. The anthropologist believed the woman to be well bred and well cared for, probably a recent immigrant. She may have been a woman of means, and she had been properly nourished, which was not a given in those hard times. The woman had been petite, with a small nose and eyes.

Anderson was busy at the time working on skulls from African American grave sites on grant funding. The group had a way of recreating the face of a deceased person from the skull, and if time and money permitted, Anderson hoped to return to put a face on this mystery woman. Since her teeth were in such excellent condition, she would see if there was enough pulp to extract from the teeth to do a DNA test. DNA databases are growing. It is possible she may be able to identify a line of this family's descendants.

Tanya Warren brought out the box, aptly marked "Human Remains," to show me the skull. It was carefully wrapped and in surprisingly good condition, though it still had a coating of the ruddy-colored dirt that clung to it. The jaw was wrapped separately and, aside from some missing teeth, appeared surprisingly whole. There were no marks or damages that indicated the woman had been struck in the head. It is unknown where the rest of her skeleton lies or if she, in fact, came from a grave a Kashong Point or elsewhere. Until more is known, her past remains a mystery.

## ATTACK OF THE MONSTERS NEAR MARATHON

In February 1805, Patrick Mallery, a strong and courageous man, and his wife settled near Marathon. They stayed with Mallery's sister while they built their log cabin, but with the coming of spring they became occupied with harvesting and boiling maple syrup, and so their cabin remained unfurnished while they worked.

One day Mallery and his wife were in the woods collecting and boiling the sap when darkness came. Perhaps they had been so occupied that they lost track of the hour, but as night fell, they boarded their canoe and crossed the river toward home.

Soon, they reached the eastern shore and started down the path to Mrs. Hunt's house, where they were staying. However, at that very moment, fear coursed through their bodies as they heard the most monstrous cries coming from the far side of the river. They realized immediately that there were dreadful creatures in pursuit of them. They were under attack, and their pursuers were not far behind. Mrs. Mallery urged her husband to run, but he, not wanting to seem cowardly, held his stout axe aloft and walked ahead, though not slowly. Mrs. Mallery urged him to progress faster, and soon the two arrived at the home of Mrs. Hunt, and they rushed inside to warn the residents of the coming attack. To their distinct embarrassment and relief, they learned that the horrendous war cries were merely owls that dwelled in the nearby woodland.

## THE WITCH AT JOHN CHAMBERLAIN'S MILL

John Chamberlain was not a millwright by trade when he came to Marathon about 1808, yet he built a sawmill near the creek equipped with all the working gears and wheels that he would need to perform the work of a millwright. Chamberlain had carpentry experience, and the mill seemed to work well for him aside from one small detail, which was the saw. Try as he might, Chamberlain would cut a board and it would begin two inches thick at one side, but by the time he arrived at the other side of the board, it was thinner than a man's little finger. He tried time and time again to correct the situation, until at last he became convinced that the mill was under the spell of evil witchcraft. Chamberlain was a God-fearing man, and he had heard of instances when evil spells had been cast over the workings of things. The more he thought about it, the more convinced he became that his mill was under the influence of witchcraft, and he vowed to eradicate the evil influence.

Now Chamberlain was not a stupid man. He knew with certainty that a witch could not be killed by ordinary means, such as by powder and ball, but that a silver bullet would certainly do the job. He set about manufacturing a silver bullet, hammering out the ball with his own hand. He loaded his gun with it and an extraordinary amount of gunpowder and crept by the mill with his gun aimed to shoot, to watch for the evildoer that might appear.

Chamberlain waited and watched for some time, but quite honestly saw nothing out of the ordinary, and so at last he fired directly at the saw itself. Due to the excessive powder he had loaded, Chamberlain was thrown backward while that magical silver bullet was propelled forward directly into his saw, which became so deformed from the blow of it that it could never be used again. It was beyond repair, and Chamberlain had no option but to employ an experienced millwright to repair his damaged mill. After that, everything worked as it should. No one could say whatever became of the witch. In later years, John Chamberlain turned to the cloth and became a Free Will Baptist preacher.

## DRUMS ALONG THE SENECA

For hundreds of years, as long as man can remember in this place, during the hot summer nights strange sounds have been heard on Seneca Lake. The Native Americans used to say that they were the thumping of their ancestors' drums, the sounds of malevolent spirits or even divine messages. Whatever the cause, it still remains unseen and mysterious. Some call the beating sounds the "Drums Along the Seneca," and others call them the "Guns of the Seneca." Their cause remains a subject of speculation even today. They are said to sound like the firing of cannons, yet no cannons are being discharged. They can be heard from either direction along the length of the lake and echo across it. Many people believe these sounds emanate from gasses that erupt in the form of bubbles from the depths of the lake. No one is certain.

Seneca Lake is itself unique. It was formed by glaciers during the Pleistocene nearly one million years ago, and this finger of the Finger Lakes stretches for thirty-five miles. But its most striking feature is its depth. It is believed that the lake is more than 630 feet deep. Some claim that the bottom has never been found, and many believe that in its great depths are hidden a number of mysteries. The lake itself holds 4.2 trillion gallons of water. It is immense. Because of its depth, Seneca Lake was home to Sampson Naval Base during World War II, which was later converted into Sampson Air Force Base

and at last became Sampson State Park. However, the lake is still used by the Naval Undersea Warfare Center as a test facility. A model of the USS *Seawolf*'s sonar equipment was tested there at Seneca Lake.

It is believed by many, but debunked by several experts, that some of the Finger Lakes are connected by underwater passages and that these connections may even span all the way to the Atlantic Ocean. They say if a man were to drown in Cayuga Lake that his body will eventually be found in Seneca Lake. Experts say that the high salinity of Seneca Lake may arise from small fissures that leak salts into the lake and not from a connection with the Atlantic. Perhaps it is its great depth, or perhaps it is its high salinity, but it is a fact that Seneca Lake freezes less frequently than other lakes. In fact, the four known times that Seneca Lake is known to have frozen over are 1855, 1875, 1885 and 1912. It has not reportedly frozen since 1912. Some attribute the inability of the lake to freeze to the amount of water being constantly fed into the lake through springs, some 328,000 gallons per minute, enough to continually circulate water and to prevent the formation of solid ice.

## THE MONSTER OF SENECA LAKE

The *Geneva Gazette* and the *Rochester Herald* reported a mysterious event in 1900. Captain Herendeen was sailing his steamship *Otetiani* along the Seneca during

the summer when he noticed what he believed to be the remains of a wrecked boat floating nearby. However, as he sailed toward the flotsam, it moved, rearing its head. The beast was serpentine and had fishlike eyes and a white belly. Two fierce rows of triangular teeth were set in its mouth, its head was four feet long and the monster's body was covered with a hornlike material that resembled the material of a turtle's carapace in substance though not in form. The captain sailed at the creature at top speed, fatally injuring it. The serpent floated on the water, dead, while the crew attempted to rope it to bring it in. However, the rope failed, and the creature sunk into the depths of Seneca Lake. The adventure was witnessed by the passengers of the *Otetiani*, which included a number of credible, prominent citizens including the police commissioner, the president of the board of public works, a professor and the manager of the phone company.

The *Geneva Daily* later published an article about the incident implying that the prominent citizens aboard had visited a number of Seneca Lake wine cellars and that the fruit of the vine had been enough to create the vivid group hallucination of the lake monster.

Some suggest that the group may have seen one of the lake's many giant carp, which enjoy flipping themselves over to sun. Various divers since have claimed to have viewed similar serpents beneath the watery surface of Seneca Lake.

## MONSTER OF THE DEEP

Somewhere deep beneath the chilly waters of Lake Champlain is said to lurk an aquatic monster of extraordinary size. The first stories of the creature, now affectionately known as "Champ," were told by the Abenaki and Iroquois Indians who are said to have left offerings to the legendary creature. They described it as a horned serpent.

The first recorded sighting of the enigmatic monster was by French explorer Samuel de Champlain, who described the experience in a chronicle in July 1609. Champlain, for whom the lake and later the monster were named, described the creature as "a 20-foot serpent, with a horse-shaped head and a body as thick as a keg." Apparently, Chaplain was not alone in seeing the monster, for since

that time there have been over three hundred reported sightings of it, as well as a few videos and photographs—all of which nonetheless still leave some ambiguity as to the nature of the beast.

The 1800s proved to be a very active time for Champ sightings. A few sightings are of particular note. As reported by the *New York Times*, a work crew was laying railroad tracks near Dresden when they noticed with horror the head of an enormous serpent arise from the lake. The crew was paralyzed with fear, but on recovering their senses, they fled the scene, and the monster fled as well. The *Times* reported that "The appearance of his head was round and flat, with a hood spreading out from the lower part of it like a rubber cap often worn by mariners." The workmen reported that the serpent's bright silver scales shone in the sunlight.

In late summer of that very same year, a tourist-filled steamboat was said to have collided with the monster and nearly capsized. The creature's head and neck were seen floating one hundred feet from the boat.

Sheriff Nathan H. Mooney was on the shore of Lake Champlain in July 1883 when he witnessed the animal at a distance of only fifty yards. He was so close that he could note round white spots inside the creature's mouth. As it emerged from the water, clearing the surface by about five feet, he noted that it was between twenty-five and thirty feet long.

Of course, back then, no simple monster could exist unmolested by that most famed of all showmen, P.T. Barnum.

Barnum, hoping to add the monster to his World's Fair Show, posted a $50,000 reward for "the hide of the great Champlain serpent." As far as I know, no one ever collected.

The reports continued over time, but in 1977 a most interesting photograph was taken by Sandra Mansi. The Mansis were vacationing in Vermont, visiting family. They resided in Connecticut. They were on the lakeshore near the Canadian edge, and Sandra and her husband Anthony watched from the shore as the children played in the water. Anthony had to go to the car, and while he was gone Sandra noticed a disturbance on the surface of the water. Then, as she looked on, she witnessed an enormous creature with a tiny head attached to a long neck emerge from the lake. Its back was formed like a hump. As she watched, its head, now extended eight feet from the surface of the water, swayed back and forth on the animal's enormous neck. Sandra thought that it looked like a dinosaur.

Soon, Anthony reappeared and also witnessed the creature. He took the children from the water, and they climbed the six-foot-high bank. Then Sandra Mansi took a photograph of the creature with her Kodak Instamatic camera. They watched as a family as the animal once again lowered himself back into the waters of Lake Champlain. When the family returned home, they displayed the photograph in their family photo album until a friend noticed it and informed a researcher, who verified that the photograph was not altered in any way.

Some people believe that Dennis Hall, who is thought to have observed the monster several times, may have actually captured a baby Champ. Hall found a foot-long reptile in a marshy location near the lake. It was unusual in form and had a forked tongue. He found the animal remarkable enough that he brought it to the University of Vermont to be evaluated. They were unable to match it with any known living reptile and subsequently lost the specimen, but Hall believes that it resembled a Tanystropheus, a semiaquatic reptile thought to have been extinct for millions of years.

Though most observers of the elusive Champ have been accidental witnesses, Joseph W. Zarzynski has actively sought the lake monster using surface observations and a variety of technical equipment including sonar, and he has used remotely operated vehicles to explore the four-hundred-feet-deep lake waters in search of Champ. He has also employed searches through scuba techniques hoping to locate the body of a Champ that could be used as evidence of its existence. As of today, the evidence is still inconclusive.

## THE TANNER PIRATES

One doesn't normally associate pirates with men curing leather for shoes, but people say that there were such pirates that lived in the Catskills. It happened like this. A trading ship carrying $35,000 in coins was headed to the

West Indies. It was believed that the money belonged to financier Stephen Girard of Philadelphia.

However, during the voyage, rumor of the money circulated among the crew, and greed reared its ugly head. The crew mutinied and, using an axe, murdered the captain. They dispensed with the first mate, bludgeoning him with an oar. The ship was turned around, and it

headed back toward New York, where the crew buried their booty on Coney Island. They then wandered off to buy drinks at a local tavern. However, there is little discretion in drunkenness, and soon the word spread about the money. The police came and arrests followed, with two of the crew ultimately dangling from the hangman's rope on Bedloe's Island. However, the remainder of the crew vanished.

Soon after the incident, two members of the crew were said to have arrived in Schohariekill flush with cash. The men had once been tanners back in Philadelphia, one would presume, before their brief and eventful episode of life at sea. The two purchased an old tannery at Devasego Falls. That area was especially rich in hemlock trees, and the bark of the hemlock was used to cure leather. They received raw leather for tanning from the Swamp firm of Cunningham and McCormick. For a year, the two men operated the tannery, but then the building caught fire and burned down. The men collected the insurance money on the building and disappeared. The area residents were convinced that these two scoundrels were, in fact, members of the pirate crew.

## DINNERTIME MASSACRE

At the end of the 1700s, the Russ family lived on Equinunk Island—Josiah Russ, Mrs. Russ and their children Cyrus,

Mary and Huldah, as well as John Johnston, who was Mrs. Russ's brother, Johnston's daughter and his son, Levi, who was married to a Russ girl.

One day, soon after setting up household on the island, six Indians called on them at dinnertime. The family was hospitable and served them the evening meal, and the Indians ate with ferocious appetites. However, as the meal progressed, the Russ and Johnston families became suspicious of their guests, who began speaking in their native tongue, to the exclusion of the rest, and laughing heartily. During the meal, the family realized that the Indians were armed with guns. Mr. Russ and Cyrus quickly armed themselves, but at that moment, an Indian sprang from the table and tomahawked Mr. Russ, who died instantly. Cyrus shot the murderer and then grabbed his dead father's gun to kill another Indian. Finally, he slammed an axe into a third.

All the while, Johnston was fighting with two Indians who, in the end, killed both Johnston and his daughter. Simultaneously, another Indian murdered Mrs. Russ. Cyrus, still armed with an axe, avenged his mother's death.

Now only Cyrus and his two sisters, Mary and Huldah, remained, as well as two Indians. Cyrus waited with his axe raised and his back to the wall. With a mighty yell, the two Indians attacked, leaping upon Cyrus, who lowered the axe, smashing the skull and brain of one of the Indians. The other ran off.

The room was a disaster with the overturned dining table, and with bodies, scattered blood and anatomical parts here and there due to Cyrus's handiwork with the axe. Huldah and Mary were horrified, as no doubt Cyrus was as well with the sight of the massacre and the loss of their dear family. The only thing left to do was to bury the corpses, and Cyrus wasted no time in doing so. When the job was complete, Benjamin and Jonathan Jones came riding in. They were the fiancés of Mary and Huldah and had ridden five hundred miles from Delaware to be wed. The two girls married, and Cyrus settled in Hancock.

## THE PANTHER AND THE BOY

In 1786, Ben Haines and his wife lived in the Hancock area. Their small son was playing by the door when an extremely large panther approached and took him by the nape of his neck, dragging the kicking and screaming child away. The child's mother heard the ruckus and, grabbing a heavy broom, nearly flew out the door in pursuit. She beat the panther so fiercely that it dropped the child and growled, baring its teeth at the woman.

The mother wasted no time in scooping up the child and with great haste returned home. The panther lay down just where it was and waited for the boy to leave the home, but the woman and the child remained safely

inside. At last, as evening came, Mr. Haines returned home and disposed of the panther with his rifle.

## ID PLEASE?

In the town of Hancock in Delaware County, the constable would verbally summon the defendants who failed to appear. For identification, he would display the justice's jackknife just as one would display a badge today, to verify his authority.

## AN INDIAN WARNING

Josiah Parks of what was to become known as the town of Hancock was known as "Bo'son" Parks. "Bo'son" was how sailors pronounced the word *boatswain*, which was exactly what Josiah Parks was. He had previously been employed as a boatswain to the British on a ship during the taking of Havana in 1762. Later, Parks moved to America, where he created a wooden canoe with iron hoops for the people of Connecticut during the Pennamite War, but the canoe was defective and burst. Parks was forced to go to Connecticut to procure an iron cannon. Instead, he married and settled on the Delaware River at Stockport, never returning to the war. He lived near numerous Indian habitations. However, when war broke out, Parks moved to Equinunk Island, hoping to be safe there in a cabin that he built.

At first there were only vague rumors of Indian danger, easily disregarded. However, an Indian friend called Old Abram visited Parks on Equinunk Island to warn him of the things he had learned. Old Abram spoke of the plans between the Tories and Indians, but Bo'son disbelieved him until Old Abram grabbed him and emphatically spoke the words "Go! They will kill you." Parks was thus convinced that he was no longer safe in his haven at Equinunk. He loaded what he could in his canoe and hid the rest of his possession in a cave. However, his wife was not able to journey, and she took to the cave as well, where their son William was born.

Soon enough after the birth, they embarked in their canoe and traveled to Minisink, where they joined some friends in safety. However, the gravity of the situation troubled Bo'son deeply. His child was dying, but his concern for his neighbors was even greater than the duty he felt to his dying offspring. Bo'son journeyed sixty miles through virgin forest, swamp and over mountains to warn his neighbors in Wyoming of the dangers of which Old Abram had spoken.

When Bo'son arrived and told his tale, however, he was not believed. Rather than receiving the gratitude of his old neighbors, he was arrested and held, suspected of being a Tory spy. At last he gained his release through the intercession of Colonel Zebulon Butler. Bo'son headed back from where he had come. Later, the swamps and forests through which he traveled would earn the name "the Shades of Death"—many fleeing for their lives lost

them there, leaving their bones unburied. Bo'son lived to be approximately one hundred years of age.

## TURNCOATS AT TONAWANDA

On the southern side of Tonawanda Creek there was a blockhouse. In August 1812, it appeared that the British and Indians had taken Grand Island, and there was fear that they would cross the creek and invade. After a few days, several hundred Indians with allegiance to the British appeared on the shore. Opposite, on the Tonawanda side, citizens and soldiers alike began marching as a display for the British. Once they passed out of sight, they turned their coats inside out and marched again to give the illusion that more forces had arrived. No one knows what the British and Indian reaction was, but they may have been intimidated. Their forces did not cross to Tonawanda.

## THE HOUSE THAT DIDN'T BURN

The blockhouse on Tonawanda Creek was burned down in December 1813 after the capture of Fort Niagara. The British forces came from the captured Fort Niagara, progressing forward and burning buildings in their path. They are believed to have burned some log cabins and a tavern; however, the home of Mrs. Francis remained intact.

The enemy tried to burn it three times, but Mrs. Francis was quite ill that day and was unable to leave her home during the invasion. At each attempted burning she would crawl down the stairs and douse the fire. The home, being made of logs and not planks, was slow to catch fire, and so each time the ill Mrs. Francis was able to put things right. The British forces did not progress much farther than Tonawanda on that raid.

## THE CROSSING

Mr. Harrington was making his way westward in the year 1815 with a little sack of clothing tied to a stick balanced over his shoulder. He had taken a boat at Oswego, disembarked in Lewiston and then followed the road upriver heading for Buffalo.

When Harrington came to Tonawanda Creek, he noticed a canoe on the opposite bank, but there was no way to get to it. He saw a log cabin standing on the distant side of the creek and hollered over to it, indicating that he wished to cross. A strongly built woman came out and answered, "Very well, give me a quarter of a dollar and I'll ferry you over." Harrington had been journeying some distance now and had little money left. He shouted back that he didn't have a quarter, only eighteen cents, but that he would pay her the eighteen cents to be ferried across. It was a deep creek. The woman called back, "No

matter. A quarter is the price, and if you can't pay it, you can stay where you are."

Harrington was bound and determined to get to Buffalo. It was a lovely day, so he removed his coat, tied it to his little bundle and into the creek he went. He lived to tell the tale.

## The Punctual Delhi Post

Delhi had postal delivery as early as 1800, and the work was originally contracted to Amon and Jabez Bostwick. Mail service was on a weekly basis, and the service ran between Kingston, Jericho (currently Bainbridge) and Delhi, though it later expanded. The mail left Delhi on a Monday, and deliveries were on Thursday. Amon and Jabez Bostwick used the Esopus or Kingston Turnpike for travel on their route. So prompt was Jabez Bostwick in his deliveries that it was said that the Honorable Samuel Sherwood who lived near the village knew the exact moment to step outside his door to receive his Thursday evening paper.

## Preaching and Reaping in Delhi

Deacon Elijah Smith was the host of the log tavern in Delhi and owned farmland nearby that was planted with wheat. One day, some tavern patrons informed him that

his crop was going to spoil and advised that he harvest it immediately. Smith said he would harvest it on Monday, but the men insisted that since the weather was good and the crop was going bad, he should harvest it now before his opportunity was lost and the crop was ruined. Deacon Smith said he would not take up a sickle on Sunday and that there was preaching at the courthouse that he must attend. The tavern patrons informed him that if he would not harvest his crop, they would do so before it was too late. To this Deacon Smith replied, "Well, if you will be so wicked, no doubt you will receive your pay."

On Sunday, the deacon went to the service while the men from the tavern harvested his wheat. Deacon Smith watched them work from the courthouse window while listening to the sermon. When the men were done, they were indeed rewarded with a sumptuous meal from the deacon and pay for harvesting his crop.

## THE BEAR AND THE HOG

Jeremiah Odell, a Delhi area resident, lost a two-hundred-pound hog in 1801. There was clear evidence that a bear had dragged it off and up the nearby hill. Mr. Odell was bound and determined to rid himself of the offending bear, so he borrowed a bear trap from Mr. John Denning and placed it by the carcass of a hog. It remained undisturbed for three full nights until the trap vanished on the fourth night. It appeared

that the bear, with his foot entrapped, had taken refuge in the spruce swamp, so Mr. Odell informed the nearby settlers and the swamp was soon surrounded by the neighbors variously armed with guns, clubs and pitchforks.

Mr. Denning, knowing that the bear's paw was trapped, walked up to the bear and took a swing at it with a club, but the bear parried the blow and grabbed Denning with its

free paw, bringing him too close for comfort. Mr. Denning saw stars, though the day was young. He sicced his dog on the bear, and the dog attacked, allowing Denning the opportunity for escape. He seized the opportunity and ran. The bear was subsequently shot, and Denning was seen by Dr. Cornelius Fitch, a local doctor, who treated the wound in Denning's thigh.

## MRS. BAILEY AND THE BEAR

Apparently bears had a great taste for pigs in those days. Mrs. Bailey in Sullivan County had a problem similar to Mr. Odell's. There was a bear that frequented the Baileys' property and on occasion would dine on the swine in the Bailey family pigpen. One evening, when Mr. Bailey was not at home and Mrs. Bailey was busying herself putting her children to bed, a terrible racket arose from the pen. There was a great squealing, and Mrs. Bailey felt sure that there was a bear in the pen once again. While she realized the danger of confronting such a formidable beast, she could not stand the thought of losing another pig, so she quieted the children and grabbed some torches from the fire and hurried out to the sty, where she clearly saw an enormous bear up to no good. Mrs. Bailey shouted with all her might, and brandishing her flames she pelted the bear with fire. The bear turned and abruptly fled, leaving the pig alive but

shaken. Mrs. Bailey returned to her house and attended to her children and chores.

## Augustus Wood and His Personal Hygiene

In Marathon, Barabas Wood and his wife came to settle in 1805. They had four sons and a daughter; the youngest son was named Augustus. Augustus was known to frequently converse with those from the spirit world and with beings others could neither see nor hear. He was a man of curious habits and various delusions. All these things were troublesome to those around him, but the most troublesome aspect of all was his complete lack of personal hygiene. His neighbors were offended that he refused to shave his beard. Augustus refused to bath and rarely, if ever, changed his clothing, leaving him outside the bounds of normal society. His family was appalled and was certain that Augustus was suffering from some form of mental illness. At last, in their great distress, they asked the neighbors to come to their aid, and a plan was devised to bring some form of cleanliness into the life of Augustus.

Answering the pleas of the family, several strong young local men agreed to make certain that Augustus bathed at least every other week. This worked for a time, but Augustus Wood soon tired of his life of personal cleanliness. In the depths of his dark, tormented mind, he devised a plan to stop the bathing ritual. Augustus took a case knife, sharpened it

on both sides of the blade and then sunk it into a handle, thus fashioning a formidable dirk. When Augustus saw the men approaching, he hid himself behind the chimney in the attic. Reaching up to the roof, he managed to pull down several bricks from the chimney and pitched them at the approaching men.

The young men called him down, but Augustus, revolted by the very idea of a bath, refused and continued pelting the men with bricks until they were forced back. Soon, however, they returned with a ladder. The climber, almost

arriving at Wood's attic shelter, was pummeled by a brick and saved from hitting the ground only by his cohorts, who managed to catch him in the nick of time.

The men then attacked forcefully, and Wood pulled out the homemade dirk, wounding Alanson Carley on the cheek so seriously that the scar never disappeared the whole of his life. At last, Augustus was captured and dunked in the river. The men washed him clean, an arduous task considering his state of filth. Though the men were able to clean Augustus, they were done with him. He was soon taken away by the overseers of the poor and lived as a pauper. In those days, the lowest bidder was given the care of the paupers at an annual auction. That was the end of Augustus's forced bathing as far as it is known.

## CHURCH, WHISKEY AND RYE

About 1812 at Freetown Corners, a Baptist Church was formed. Church was important to folks in those days, and people would walk six or seven miles to attend a service. For several years, Elder Timothy Shepard, who lived near Upper Lisle, preached at Freetown corners at the Baptist Church. Later, the church split, and a new church society was formed at what later became known as Texas Valley. Elder Shepard became pastor there at the new church but was paid quite poorly for his services. His salary was paid in corn and rye at barter price, and it is said that Elder Shepard would

have his wages delivered directly to the distillery, which was owned by a member of his congregation. After the grain had been fermented into whiskey and Elder Shepard took what he needed, he would sell what remained.

## MR. BRINK, THE MUSICAL PLOWSHARE AND THE PANTHER

In the spring of 1800, Abram Brink moved to the village of Marathon after traveling up the Susquehanna River with his furniture and family in a canoe. Brink was a stout, hardworking man, the son of patriot Captain William Brink. Soon Abram Brink set about clearing the wilderness and setting up a tavern, which he operated for the rest of his life.

One day, Abram Brink was returning from a trip to Lisle. He was walking with a plowshare across his back, which had just been in for repairs. As he entered the forest, though, he became alert to the footsteps of an animal stalking him. The path was narrow, and at times the animal came so near that he could see the reflection of light in its eyes, though he could not visualize the beast. This unnerved him, and he began shouting at the creature, but it continued to follow him in the dark woods. At last he found his way out of the woods, still intact, when it occurred to him to lay down the plowshare and beat it with an iron bolt. Where his shouts had failed, the clanging of the plowshare sent the animal

back where it had come from, and it returned to the forest, much to Mr. Brink's relief when he realized that the animal stalking him had been a panther.

## A MAN'S LAST BREATH

On December 30 in 1813, Israel Reed, from the town of Wales, died in battle at Black Rock and Buffalo. Reed was scheduled for guard duty the day on which his regiment was ordered to march, but he persuaded another man to switch places with him, and Reed left for battle. Israel Reed was not a young man, but rather a man of middle age, and he suffered from asthma. Still, Reed stood in battle when most others fled. At last, he retreated with Private Emery, but the Indians were by then near at hand. The two men retreated, but due to Reed's asthma, they did not flee quickly, with Emery matching the slower gait of his companion. Eventually, however, Reed could not catch sufficient breath and pleaded Emery to speed ahead to safety, leaving him behind since he could travel no farther. Emery left with haste, leaving Reed sitting alone on the log.

Israel Reed was later discovered near the log where Private Emery had left him. He had been shot, tomahawked and scalped. His musket was found near him fully loaded. Apparently he had not offered resistance.

## MURDER IN MASONVILLE

Mrs. McCrea was a widow. She hired Mr. and Mrs. Pangburn to perform farm labor for her. Mrs. Pangburn was in the barn loft, mowing oats from the harvest that her husband was pitching to her from the wagon parked below. At one point, Mr. Pangburn left the barn and went into the mansion house, where Mrs. McCrea saw him wash his hands. He then returned to the barn but soon came hurrying back into the house, declaring that his wife was dead on the floor of the barn.

Mrs. McCrea rushed out to investigate, indeed finding Mrs. Pangburn dead, her body strewn on the floor of the barn a few feet removed from the wagon, and Mrs. McCrea suspected that Mr. Pangburn was the culprit. During an inquest, most believed that Mr. Pangburn had murdered his wife, but nonetheless there was some doubt, and so Judge Peter Pine, a coroner from Deposit, was asked to investigate. A surgeon and a jury were also assembled, and the body of Mrs. Pangburn was exhumed. The barn floor, the body and other evidence were taken into consideration, as well as the accounts of witnesses. Unanimously, the jury decided that Mr. Pangburn had willfully murdered his wife with three blows to her head with an ironwood flail swingle that had been found in the weeds near the crime scene. The body suggested that Mrs. Pangburn's nose had been broken, and she had also been clubbed at the eyebrow, leaving hair on the murder weapon as evidence. Additionally, she had been

beaten on the top and back of her head, causing her skull to fracture. Mr. Pangburn was tried but inexplicably acquitted.

He later removed to the West near Mississippi, where he was married again. His second wife was subsequently found dead. There Mr. Pangburn was tried by Judge Lynch and hung according to the ways of frontier law.

## AMERICA'S FIRST CHEESE FACTORY

In 1851, Jesse Williams founded America's first cheese factory near Rome, New York. Prior to Williams's operation, sweet cheese was produced on individual farms and by families. Williams's factory made cheese from scratch, producing some of the milk from his own herd of dairy cows and purchasing milk as a raw material from dairy farmers. Prior to Williams's cheese factory, some producers would purchase cheese curd and make cheese from that, but the results were variable. Williams's operation produced the curd, creating a more consistent and regular cheese. Factory cheese was known to have uniformity in texture and taste, which may have made it appealing to some.

When the Civil War broke out, many men left the farm to fight for their country, leaving farms short-handed. This in all likelihood helped to accelerate the proliferation of cheese and butter factories, since milk could be sold in its raw form. The dairy industry expanded throughout the area. Even today, dairy cows are a common sight in the region.

Today the Erie Canal Village, located in Rome, New York, houses the New York State Museum of Cheese, which helps document the history of cheese making and its relationship to the Erie Canal. The Museum of Cheese is not Jesse Williams's old factory, but rather the old Merry and Weeks cheddar cheese factory that was moved from Verona, New York. Erie Canal Village is an outdoor living history museum that features a variety of nineteenth-century structures to give the visitor a feeling of stepping back in time. The site features a canalboat ride pulled by mules along a strip of the canal, as well as a tavern, blacksmith shop, icehouse, Victorian church and other relevant buildings.

## THE REPUBLICAN FLAGPOLE

Dave Fuhrer, the proprietor of the Only Café in Vernon, took a trip to Palmyra. There near the street, he noticed an American flag flying over what appeared to be a metal structure that resembled something like a cross between a small Eiffel Tower and an oil derrick. He asked what the devil that thing was, and a local replied that it was the Republican Flagpole. Dave motioned to a flowerpot across the street with a diminutive American flag flying in it. "And I suppose that is the Democratic Flagpole?" No, no, said the man about the strange metal structure. That really is the Republican Flagpole. The Democrats and Republicans

used to have separate flagpoles, and they were constantly burning each other's down, so the Republicans built an unburnable, practically indestructible flagpole.

Historically, the flagpole flew not an American Flag but rather political banners promoting Republican candidates. Flagpole-raising day was on October 25, 1882, and was accompanied by rousing speeches, an enormous parade, bands and other forms of celebration. The Democratic Flagpole no longer exists, and the Republican Flagpole is now property of the village and flies an American flag rather than banners promoting candidates for office.

## FRANCIS BELLAMY AND THE PLEDGE OF ALLEGIANCE

Francis Bellamy was born in Mount Morris, New York, in 1855, but in 1859, David Bellamy moved his family to Rome, New York, where he ministered to the First Baptist Church. Francis Bellamy went on to write the Pledge of Allegiance, while his cousin Edward Bellamy became a socialist novelist and author of such works as *Looking Backward* and *Equality*. Young Francis Bellamy attended school in Rome, including at the Rome Free Academy, then in 1872 he went on to enroll in the University of Rochester to become a Baptist minister. Following graduation in 1876, Bellamy entered the Rochester Theological Seminary and later accepted a position at the Baptist Church of Little Falls, where he preached temperance, among other things.

Francis Bellamy was a Christian socialist who believed that the government should nationalize the economy.

In 1885, Bellamy moved to Boston, Massachusetts, where he would minister at the Dearborn Street Church, whose congregation consisted of numerous impoverished factory workers. His social work drew the attention of Daniel Ford, who published *The Youth's Companion*. By 1890, Bellamy was preaching at the Bethany Baptist Church. Ford was impressed by Bellamy's socialist sermons. Bellamy was active in his cousin's nationalist movement, and at last, Bellamy's church was rebuked financially because of his socialist ideology. Bellamy resigned and went to work promoting Daniel Ford's *The Youth's Companion*. Bellamy was asked to work with James Upham on the National Public School Celebration for the upcoming 400th anniversary of Columbus Day. Upham believed that having the flag in school would increase patriotism among young people. The two men planned to create a flag ceremony to promote this patriotism that would center upon a flag salute.

There seemed to be interest among the schools for patriotic programming surrounding a flag ceremony, and Bellamy was able to gain support of the Superintendents of Education of the National Education Association, among others. Newspapers were supportive of the project as well, and Bellamy was named as chairman of the National Education Association's executive committee for the Columbus Day event. An incredible public relations campaign was waged that included press releases and mass

mailings. General John Palmer, who was the commander of the Grand Army of the Republic, Theodore Roosevelt, Grover Cleveland and President Harrison all endorsed the program. *The Youth's Companion* asked readers to purchase flags for their schools in preparation for the celebration.

Bellamy prepared an eight-part program for the Columbus Day Celebration, but the focal point was to be a salute to the flag that Upham planned to write. Though he tried many times, Upham was unable to create a salute that he felt was worthy, so he passed the job to Bellamy. The Pledge of Allegiance as Bellamy originally wrote it is as follows: "I pledge allegiance to my flag and the Republic for which it stands, one nation indivisible, with liberty and justice for all."

A month later, Bellamy changed the pledge by adding "to" before "the Republic." The pledge was performed by students with the right arm outstretched upward toward the flag with the palm facing downward. When the students speak the words "to my Flag," the palm was then changed to an upward position and remained as such until the end of the pledge, when the arm was returned to the side. This salute was changed during World War II to being recited with the hand over the heart. The initial part of the original salute would by then resemble quite closely the salute used by Nazi Germany.

The Pledge of Allegiance was published in *The Youth's Companion* anonymously per the policy of the magazine. Flag sales were soaring, and awareness of the magazine and

subscriptions increased dramatically. Over half of the nation's schools participated in the flag ceremony for their Columbus Day celebration. The program was an unmitigated success. The pledge continued to be a mainstay in the schools and came to be recited even once Columbus Day had passed.

The American Legion and the Daughters of the American Revolution worked to change the wording of the Pledge of Allegiance in 1923 and 1924 from "my Flag" to "the Flag of the United States of America" since at the time there was a growing immigrant population, and some people believed that there may have been some ambiguity about what exactly "my flag" meant (despite the fact the saluter is standing directly in front of an American flag with his hand extended out toward the same flag). Francis Bellamy found the change to "the flag of the Untied States of America" repugnant.

The Knights of Columbus supported the addition of the words "under God" in 1954, but this campaign did not gain momentum until George MacPherson Docherty, a pastor at the New York Avenue Presbyterian Church in Washington, D.C., took up the cause. MacPherson was a Scotsman, not a U.S. citizen. One day, his seven-year-old son came home from school and recited the pledge. Docherty was appalled that God was not mentioned in the pledge and so preached a sermon about it.

Later, when he knew that President Eisenhower would be attending his church on February 7, 1954, he repeated the sermon, preaching against "godless communists."

The following day, Representative Charles Oakman (R-Michigan) introduced a bill in the House to add "under God" to the pledge. Senator Homer Ferguson (R-Michigan) introduced the Senate bill. This was in large part seen as a way to differentiate Americans from Soviet Communists during the Cold War era. This additional phrase has been challenged in various court lawsuits over the decades. Eventually, Docherty relocated back to Scotland, but he later returned to America once again with his family.

## FATHER MCCARTHY: THE CARNIVAL PRIEST

Oddly, I first heard of Father McCarthy a long way from home. I was helping install a fifteen-foot puppet at a conference in Las Vegas, and I picked up the *Amusement Business* trade paper and stuffed it in my bag to read later. At my leisure, I scanned the ads and started when I saw one that referred to Watertown, New York. It was an advertisement for a book called *The Carnival Priest* that was sold by the sisters of the Precious Blood Monastery in Watertown. When I returned, I called and ordered a copy. It told the story of Father Robert McCarthy, and I learned for the first time of the Showmen's Chapel in Watertown. On one occasion, after performing a puppet show in the North Country, I searched for the chapel in Watertown, lured by the story of a small showmen's museum there. Indeed, outside the monastery, near the parking area is

a large glass case displaying artifacts from Father Mac's lifework ministering to the carnival people. Among many other objects displayed was a beautiful carousel horse.

The Showmen's Chapel is minuscule in size, modernistic in design and separated into two sides, one for the sisters and one for visitors. Perhaps the most remarkable thing about the chapel is not its shape, design or other physical attributes, but its origin. They say this chapel was built by Catholics, Protestants, Jews and with money from people from numerous denominations. All were ministered by Father Mac during his many years on the midway. Today, now that Father Mac is gone, the sisters sell copies of his biography to raise money to support the monastery, since the monastery is required to be self-funding. It receives no money from the diocese. There are perhaps 100,000 carnival workers in North America, manning four hundred carnivals, and the monastery receives little of its operational money by offerings since carnival workers are itinerant. At times the monastery's fundraising attempts have been surprising and unique, such as the fundraising drive it had with performances by the Hell Drivers.

Father Mac became enchanted by the carnival people as a boy. In September of each year, the local fire department would host a carnival, and the McCarthy family always attended. It was the kind of carnival that comes to smaller locations, with a carousel, the Whip and plenty of sideshows with carnival barkers outside talking up the show to the crowd. Young Robert was so impressed by this that he took

a job as a carnival talker. He genuinely liked carnival people and enjoyed associating with them. He also enjoyed oratory. Eventually, in 1946 Robert McCarthy became a priest.

One day, he went to the carnival grounds to ask for some free tickets to give to poor children. Father Mac was overwhelmed by the outpouring of generosity of the carnival people, and he never forgot that. Later, after Father Mac had been a guest at the National Showmen's Association and had served as an outstanding announcer, he was asked to become the National Showmen's Association's chaplain. It was a remarkable offer, as most of the Showmen's Association happened to be Jewish, but Father Mac seemed to have a rapport with the people. This opportunity began Father Mac's lifework with the carnival people.

Father Mac preached wherever he could—in bars, girlie tents, freak show tents and bingo tents; aside from the bars, these were desirable venues because of their larger size. He has offered mass from the back of a truck, in open fields, on rides, in beer halls and in nightclubs—in short, wherever there was space he made his church. Oftentimes, a few cases of beer would be stacked and then dressed with the altar cloth to hold the candles and sacred vessels in preparation for Mass. Father Mac himself was notorious for wearing a T-shirt advertising beer or some such thing underneath his vestments. He did not receive official Vatican sanction for this work until 1978, but in time he became the official chaplain of carnivals, Victor Apostolic, or the bishop to the show people.

He ministered to people of all religions regardless and performed services, baptisms and funerals. Funerals were generally held at the end of a carnival season when the dead were buried in one of several showmen's rests throughout the United States.

In the meantime, wherever he traveled, Father McCarthy would be on the radio or television or talking to the paper, and he always had the same message. He preached the worthiness and kindness of the carnival people, a people he believed were chronically misunderstood.

## A NEW YORK POET IN BORNEO

Deep in the stacks of the Kroch Library at Cornell University, a very special collection is housed that can be found nowhere else. There lies the collected work of Carol Rubenstein, poet and researcher to seven ethnic groups in Borneo. Carol's story began during the time of the Vietnam War. Carol, a New Yorker, graduated in 1969 from Bennington College, and in 1970 she obtained her master's in poetry from the Johns Hopkins Writing Seminars. Following her graduation, she began traveling in Southeast Asia. At that time, she was unsure of the direction her life would take. She traveled into Vietnam, Cambodia and other locations but found herself deeply troubled by the things she witnessed and longed for an environment that reinforced life and not death. She wanted to get in touch

with the natural world, and so she journeyed to Borneo. And Borneo, indeed, had a healing effect on her. It made her feel human once again.

Carol had been traveling in Sabah, an East Malaysian state, for two months when she arrived in the neighboring state of Sarawak. She read some folk tales published by the Borneo Literature Bureau, and Carol asked the museum director who published its poetry and where she might read it. She was directed to the Sarawak Museum and told that she could find the Dayak poetry there. However, upon arrival she was shown that the museum had stacks of recordings and no one to translate it. There was no one with the patience and the gift of poetry to do the work. Carol asked if she might work on some of the poetry, and a staff member, Raphael, whose native name was Nyandoh, liked the idea. They initially worked on two or three short chants. Then Carol asked if they had anything that was a blessing for a house. Raphael said that, indeed, there was going to be a house blessing soon and that they should arrange to go.

She was given a corner and a mat to sleep on (she brought her own sleeping bag) in the headman's house. In the following days, Carol and Nyandoh could watch and record the house-blessing ceremony. They went through it phrase by phrase, looking for meanings, and slowly they were able to translate the ceremony into English, which was the official language of Borneo at that time. When several of these works had been translated, the museum was pleased. Carol applied for a grant backed by the museum and began living among the

indigenous peoples about 1971. The Ford Foundation, which had an office in Bangkok, approved the grant. Soon the grant cycles determined her living cycle. Carol would live simply, among the people, absorbing, learning and recording.

The people began to trust her. Unlike the anthropologists who concentrated on kinships and society, Carol expressed a true and genuine interest in their poetry, epics and chants. Every six months, Carol would have to reapply for another grant with the Ford Foundation, and she did so for three years. The Dayak groups were originally headhunters, but that had been legally banned after World War II by the British. However, the Dayak groups still maintained their head collections, and over the chief's door would be netted a bundle of heads. Many of their poems revolved around the heads and the feeding of the heads, which were thought to give power to the collector. Most were stored and maintained in the head house.

Certainly, there were many other types of poems, as well. Perhaps the most important ones concerned the growing cycle of rice, their most important food staple. The religion of the people was very much tied to the growing of rice, and its cycle was reflected in their poetry. There were songs for dibbling of the rice, seeding, weeding, harvesting and many other types of rice songs. There were also love songs, lullabies, songs for the dead, songs to name a child and to bless a child, marriage songs, hunting songs, traveling songs and pig slaughter songs, as well as many others, expressing numerous aspects of their lives both secular and religious.

At first, Carol had some difficulty convincing the people to share their more warlike songs and poetry because the Dayak had been influenced by Christian missionaries who insisted that they not sing their traditional songs any longer, but Carol won them over by telling them it was for the museum. Then the people became more open to sharing that part of their heritage with her.

In 1976, Carol returned to the United States and visited the Southeast Asian Studies Department at Cornell University to do a reading. The school liked her, and the feeling was mutual.

In 1984, she received a National Endowment for the Arts (NEA) grant in literary translation, and in 1985 Carol Rubenstein returned to see how the former singers were doing. What she witnessed was a tremendous cultural loss. In 1974, the government had become involved in logging concessions. The government claimed that the people had no deed there, though they had been living on the land traditionally. The loss of land and forest caused tremendous cultural loss to the people. The young could not work in the traditional way, farming the rice paddies, and often had no option but to join a logging company, with some girls becoming bar girls. Much of their own oral tradition was lost, along with their way of life.

Traditionally, only certain people would be tellers of the epic tales. In many instances, those older individuals had died without passing on the tradition to a new generation. In other instances, the tellers had not performed the epic

tales for so long that they could not remember them. There was great poverty, both economic and cultural. In many instances, the only record of these traditional stories were the stories recorded by Carol on tape and subsequently translated into English. Only there, in the Kroch Library at Cornell, do many of these poems and songs still live.

Carol Rubenstein won a fellowship at Cornell's Southeast Asian Department to work with her papers at the Kahin Center. In 1998, she finally completed her archiving. Her work may be viewed, and the original sounds of the people of Borneo may still be heard on tape there, at the library in that remarkable collection.

## ABRAHAM LINCOLN IN TROY

This is the transcript of an 1861 manuscript owned by the author of this book. Though it is unsigned, it has been identified as written by C.H. Wilke by John E. Boos, a Lincoln collector in Albany, New York:

> *Abraham Lincoln when he visited Troy on the morning of February 19th, 1861 was given a salute of thirty-four guns fired by the Troy City Artillery.*
>
> *As soon as the cars entered the station a guard of honor was given him by the Troy Citizen's Corps. A crowd estimated at not less than thirty thousand were on hand to greet Mr. Lincoln. In a brief address by*

*Mayor Hon. Isaac McConihe the future president was welcomed to Troy. The president responded and made a lengthy oration from the back platform of the train.*

*As the train left the station, Mr. Lincoln stood with uncovered head waving his hand to the multitude of cheering people.*

## Buffalo Head

In Forestport across from the old train depot is a restaurant known as the Buffalo Head. According to the restaurateurs,

tradition says that logging crews used to be transported by rail to the Adirondacks to work five days per week and were returned home to the city by rail for the weekends. One day in 1924, an Italian immigrant logger was told by his wife, in no uncertain terms, that he must remove the stuffed buffalo head from their apartment. The husband complied and took the buffalo head on the train, disembarked at the train depot, and with the assistance

of some friends, he nailed the thing up at the train station. From then on, it served as a landmark for non-English-speaking immigrants. When needing to know the depot where they should disembark, they would simply ask for "Buffalo Head"—hence the name of the restaurant today. To my knowledge, it does not serve buffalo.

## THE ONEIDA COUNTY MEDICAL SOCIETY

The Oneida County Medical Society was formed on July 1, 1806, when twenty-nine Oneida County physicians met in Rome, New York. Though the society had multiple purposes, perhaps most importantly, it served to license area physicians and continued to do so until 1878. Later, in 1890, the Board of Licensure under the State Department of Education issued medical licenses.

The Oneida County Medical Society gained its licensing authority through New York State legislation that dictated the licensing of medical practice through local County Medical Societies.

Back then, medical practitioners would work their way to patients over miles of wilderness often without trails by horse or foot or by using native snowshoes. Often times, these "doctors" were minimally skilled or even completely untrained. Understanding the physical damage that could occur from these men masquerading as professionals, New York passed legislation to license their practice, and the

Oneida County Medical Society was formed as a response to the need to provide quality care through the requirement of medical licensing.

## Dr. Lewis: Innovative Vernon Doctor

In the village of Vernon, the library is located in a small building on Peterboro Road. The building itself was never designed to be a library; rather the building was the historic stable of Dr. Lewis, an early doctor in Vernon. Upstairs in years past, there was a small display of Dr. Lewis's desk, his valise and a variety of the tools of his trade, including old bottles, compounding tools, and so on, that have vanished with time. For years these items could be viewed upon request, maintained by the Vernon Historical Society. Furthermore, it has long been told here in Vernon that Dr. Lewis had invented pink bismuth, known today as Pepto-Bismol. Lewis's life was well documented by his daughter Breta Lewis in a paper that is now preserved by the Vernon Historical Society, and Dr. Lewis's story is an interesting one.

Lewis was born on September 17, 1855, in Orleans Corners, New York, and was the son of a Methodist minister. The family later moved to La Fargeville and then to Verona. Young Lewis yearned to be a doctor and was sent train fare from his Illinois grandfather to travel to Ann Arbor, Michigan, to study medicine. Lewis took the day coach to Ann Arbor, placing his suitcase on the edge of his

seat with his coat rolled up on top of it so he might use it as a pillow on the journey. He studied in medical courses from 1876 to 1878 at the college in Ann Arbor and lived with other budget-minded students who formed a club of sorts, sharing expenses for food, a cook and paying a student to wait on the tables. Each heated his own room with wood he found or purchased himself.

In 1878, Lewis returned to Verona and then attended New York University for a year, subsequently interning at Welfare Island Hospital for an additional year, at last graduating in 1879. His living arrangements in New York were similar to those in Ann Arbor, and once again he banded with other students in a club that featured shared living expenses aimed at cost cutting.

After his return from New York, he married Miss Jessie Leete and began searching for a place to practice. They temporarily lived in Turin, and later he worked at what was then the insane asylum in Rome, but he left there after only six months for there was little to be done for the mentally ill at the time other than incarceration. Lewis then moved back to Verona and, in 1881, moved to the village of Vernon, occupying a two-room building with his office at the front and his living quarters in the rear. During this time, his wife Jessie remained with her parents in Verona. Dr. Lewis ate with the property owner, Mrs. Nye, and her family while he lived in her building. However, this arrangement did not last long, as a nearby property, a house at 27 West Seneca Street, soon came up for sale. Lewis borrowed the necessary funds from

Tommy Tucker and from his own father and purchased the house. Lewis and his wife lived there, never moving again.

Lewis went into the practice of Dr. Isaac Freeman as a new doctor to "read medicine," or learn how to practice medicine from a practicing, established doctor, though back then the practice of medicine was severely limited since the understanding of the causes of disease, and the development of antibiotics and other treatments, had not yet become established. Breta Lewis tells that her father was heartsick watching so many children die in epidemics when he had no cure to offer. Still, as time progressed, Lewis kept abreast of medical developments by reading current journals. He purchased a microscope and learned to stain and read slides. He owned and used a type of static machine and offered electrical treatments to patients. He was known to have owned a fluoroscope and an X-ray tube and prided himself on impressing people, revealing hidden metal objects through an X-ray.

Though these days, doctors are thought to have healthy incomes, it was not necessarily so back in Dr. Lewis's time. His was a labor of love, and to support his practice of medicine he often had to take on additional jobs. Money was not plentiful then, and Dr. Lewis was often paid by the families of the sick in food such as fruit, vegetables or meat.

Dr. Lewis also served as a dentist since the village lacked one, and he was ready to extract a tooth when it was needed. In one anecdote, a man came in to have a tooth removed but, fearing the pain of it, hollered for the doctor to wait.

The man hurried out toward the hotel next door for a shot of something strong, but the good doctor called him back, promising to give him something for the pain. Lewis offered him his own whiskey and then dutifully extracted the offending tooth. He later explained to his daughter that he had charged the man fifty cents for the tooth extraction but served him a dollar's worth of whiskey.

Since the area lacked a veterinarian, Dr. Lewis treated a variety of domestic and barnyard animals. Apparently, he had a good reputation in this respect as well.

Dr. Lewis also served as coroner for a time. One of the most memorable events as coroner was the case of the murder of Norton Metcalf. These are the circumstances of the case. Virgil Jackson had an affair with Norton Metcalf's wife. One day, the two men met on the street, and during a scuffle Norton Metcalf was shot.

Virgil Jackson was arrested and taken to jail in Utica. He claimed that he shot Metcalf in self-defense. Breta Lewis tells that Jackson was taken by horse-drawn wagon to Oriskany Falls, and then the remainder of the trip was made by train, all the while in the custody of Deputy Sheriff Burke. The following day, the defendant was returned to the Presbyterian Church in Augusta for the coroner's inquest, where he pleaded "not guilty." There in the church basement, before a jury of nine, witnesses were called, and Jackson was interrogated by both Coroner Lewis and the district attorney. Drs. Munger and Higgs, both of Knoxboro, were called to testify, and in the end,

Virgil Jackson was found guilty of the premeditated murder of Norton Metcalf and returned to the Utica jail.

As for Norton Metcalf, he was buried in the Knoxboro Cemetery after a standing room only funeral at the Augusta Presbyterian Church presided over by Reverend H.H. Dodd, the pastor of the church, with the assistance of Reverends Waterman and Warner of Oriskany Falls.

Before 1813, Vernon had no permanent pharmacist, so Dr. Lewis served as that as well, compounding his own drugs and keeping medicines on hand in supplies of one to five thousand tablets. He also was known to have stored liquid drugs by the gallon. However, when the Stone Store opened, Mr. Salmon Case began selling pharmaceuticals there. Lewis, in his isolation as a doctor, was inventive to be sure, and he created a machine to split twelve-inch-wide adhesive tape into a one-inch width. It is known that he created a lotion for the treatment of eczema, which was later bought by Norwich Pharmaceutical. He is said to have compounded a drug for the treatment of headaches and fevers and also created a nasal lotion for the treatment of the common cold.

Lewis was an agent for the Aetna Fire Insurance Company from around the mid-1940s until 1954, when he sold his agency. He served as medical examiner for a wide variety of life insurance companies and even had a piano agency to help pay the bills for a while.

In the early days of Dr. Lewis's practice, there was no nearby emergency facility or hospital, so an upstairs room was

had no children. At that time, Alice was perhaps sixty years old. She didn't know what to do, so Owen said to come to New York. She was not even given the opportunity to liquidate her own property because Owen wished her to come immediately. Instead, Joanne sent some things to her that she thought she would want.

Owen was worried about what would happen to his property if he died, and his financial advisor advised that he should marry Alice since they were sure she would do what he wished with his money. By then Owen was in a walker, and Alice was much younger than he was. The couple obtained a marriage license and returned to Owen's apartment, where a priest married them.

Alice's time in New York was anything but glamorous. Though Uncle Owen possessed millions of dollars, they dressed in rags and threadbare clothes. The furniture was patched with duct tape. No workers or repair people were allowed in the apartment because it might distract Owen's train of thought. For an unknown reason, Owen would remove the fixtures from lights, leaving the bare bulbs. He removed bookcases from either side of the window and paid somewhere between $3,000 and $5,000 a year to store these fixtures. Meanwhile, Owen and Alice lived out of cardboard boxes stacked to the ceiling and covered with sheets. Owen never went in the boxes—rather he would have Catherine, and later Alice, retrieve things from them.

Alice would dress in Owen's old, worn T-shirts and tattered shorts. She had good shoes but wore ones with

holes in them. They never spent money on themselves. Additionally, Alice had to account for every penny she spent. If Owen sent her to buy bread, she would need to return with change and the receipt. Inevitably, however, Owen would complain about the price she paid.

Once, Joanne remembered that there was a mouse infestation, and she paid twenty-seven dollars for mouse bait. Owen phoned her at 11:00 p.m. grousing about how much she had paid and complaining that the mice ate better than he did.

Owen never wanted to leave the apartment for any reason. Kate had, during her marriage, been on occasion able to convince Owen to take a vacation. However, they could not simply go and get a hotel room. It had to be a particular place and a particular room. To ensure that they had the room, Owen would rent the room for the entire season. When they left for a trip, they would be the last to board, and at the final moment, Owen might decide that they would not go. Once, Joanne remembers, Alice had to go to close an apartment that they were renting. He had her fly out, take a cab, keep the cab outside while she cleaned out the apartment and immediately take the plane back to New York. Owen could not bear to be without her.

Owen practiced law until he died, getting assessments lowered for large corporations. Alice would show up in court for him since Owen seldom appeared. When Owen died, Alice knew all about the law firm and all aspects of his business.

readily converted into a surgical room. This was later moved downstairs for matters of convenience until the Broad Street Hospital in Oneida was built. Still, until then—and especially after the advent of the automobile with its glass windshield that could shatter, wound and lacerate—Dr. Lewis's small emergency facility proved necessary and often effective, though the help there was often untrained in the medical profession. Accidents were especially high after a rain, when roads became slick with oil and cars would hydroplane.

Then as now, Central New York received abundant snow, and in the days of the house-call doctor, arriving at a patient's quarters in winter proved impossible sometimes. To ease winter travel, Dr. Lewis purchased an early snowmobile that prompted many stares from the local folks. It had the body of a Ford roadster, but there were runners instead of front tires and caterpillar treads with four inside wheels on the back. This method of winter locomotion worked sufficiently well until road care improved and the strange vehicle proved unable to drive on snow-free roads, at which point Dr. Lewis abandoned it.

Throughout his sixty years of practice, Dr. Lewis is believed to have delivered nearly two thousand babies, although he apparently did not keep records of such. Usually he was the only professional in attendance, unless a midwife was present.

There is no doubt that Dr. Lewis was a busy man. Nonetheless, he taught himself to play the violin and paint with oils and experimented with a camera and photography, adding a darkroom to his basement. Lewis contributed

to the area's medical history and served as an inventive medical pioneer in New York State.

## JUMPING SAM PATCH

In the days of the canal, there was a young man named Sam Patch. Patch had been born in Pawtucket in 1807 and later worked at a mill as a mule skinner. In 1827, he jumped from the top of Old Yellow Mills, near a waterfall on the Blackstone River, and received some acclaim for that. There, it is said, he first spoke his most remembered retort, "Some things can be done as well as others." But the powers that be declared such daring jumping to be unsafe and forbade further leaps. Sam Patch left town, never to return.

Patch turned up in Patterson, New Jersey, where he planned to jump from a seventy-foot bridge, but the police prevented it, so instead Patch jumped from a rock above it and later managed a jump from the bridge itself. Soon, word of the amazing Sam Patch began to spread, and he found himself offered numerous opportunities to jump. Sam kept a pet black bear and began to use it as part of his jumping act, pushing the bear over the waterfall as well. The bear was never as inclined as Sam to jump over dangerous cataracts and such, but the crowds were impressed.

In the year 1829, there were rumors that a man by the name of William Morgan had been kidnapped in Niagara

Falls and possibly murdered for revealing dark Masonic secrets and even rumors that his body had been thrown over the falls themselves. These suggestions were enough to depress the area hotel business rather significantly, and so a great festival was planned to revive interest in the falls. After all, the Erie Canal made the dramatic Niagara Falls quite accessible to people. Sam Patch was invited to jump over Niagara Falls, a schooner was to descend the falls and there was to be a great explosion as well. Sam didn't show, the schooner ran aground on an island and the explosion went almost unnoticed next to the majestic thunder of the falls. The next day, however, Patch did jump from the half-destroyed platform 125 feet above the raging waters below, first singing a song and dancing a small jig on the rickety platform. Then, with a liberal swig of whiskey from his flask, he dove gracefully into the waters of the falls below.

Sam Patch's fame catapulted. More opportunities came flooding in.

Patch's next jump of note was at the Genesee Falls in Rochester, but arrogance and strong drink proved Patch's downfall. Seven thousand appeared to watch the daring young Patch in what would be his final leap. Now he had attired himself in white tights with pantaloons, and a large black sash was displayed jauntily over his shirt and vest. He wore a cap and was extremely drunk. Sam Patch, previously a man of few words, began his speech:

> *Napoleon was a great man and a great general. He conquered armies and he conquered nations, but he couldn't jump the Genesee Falls. Wellington was a great man and a great soldier. He conquered armies and he conquered nations, and he conquered Napoleon, but he couldn't jump the Genesee Falls. That was left for me to do and I can do it and I will.*

Perhaps because it was Friday the thirteenth, or perhaps because Patch feared the Falls themselves, or perhaps because he recognized his own drunkenness—whatever the reason, he had requested that if something happen to him that day a collection to be taken up for his mother.

Sam leaped from the twenty-five-foot-high scaffolding, and the dive began well, but then he began to flail and rotate, at last hitting the water with his arms and legs extended outward. He sunk, and search as they might, his

body was not found until St. Patrick's Day. It had floated six miles from Rochester and was found when a farmer went out to break the ice to provide water for his cows. There he lay, his body broken and arms torn from his sockets, identifiable by his black sash that had proved such a fitting costume for his final leap.

Patch died on November 13, 1829. His body was buried in Charlotte Cemetery in Rochester beneath a marker that read: "Here lies Sam Patch, Such is Fame."

## UTICA: CITY OF GANGSTERS

This story was heard from an older gentleman—we will call "M." When M. was a boy in Utica, one of the most exciting moments of his life was when he entered a restaurant in Utica and saw Al Capone. Capone motioned the boy over and then lifted him onto his lap and gave him a shiny silver dollar.

Back then, organized crime ran a number of gambling operations scattered in hidden places throughout east Utica, which was then occupied primarily by Italians. Gambling operations were often hidden in shops and in the backs of buildings, in an upstairs room or in a room that was ostensibly a storage room. There gaming would take place with wheels, card games and bookies. M. worked as a type of errand boy or messenger to the mob, or the organized crime around town. When he was a bit

older, they bought him a shiny red bicycle so he could do his errands faster.

One day, he was going to deliver a message to one of the stores in which there was a gambling facility in the back room, but before he could enter, someone grabbed him and dragged him off into an alleyway. He thought he was being robbed, but the man put his hand over the boy's mouth and whispered "Shhh." Soon, the police sirens could be heard, and law enforcement raided the building. The mob had been tipped off and when the police entered, there was no one there and the place was empty. They were able to arrest no one.

## IT'S POURING IN UTICA

A local expression in the Utica area that harkens back to the area's days of organized crime is "Why waste a good pour?" Here, a pour refers to the pouring of concrete in the formation of building foundations, etc. The expression suggests that the pouring of concrete in construction is a good way to dispose of a body undetected.

## A GYPSY KIDNAPPING

"Carrie" told me this tale and wished not to be identified or have her family identified by name in the book. This is a story of Carrie's grandfather—a law enforcement officer,

she believes that he was a sheriff—and her uncle when he was a tiny boy.

About 1918, a three-year-old dark-haired boy vanished while playing in Sylvan Beach where he lived. Gypsies had been seen traveling through the neighborhood a short time before, and the father of the child, a sheriff, went off to find his missing son. The sheriff was an exlumberjack and a sports hunter who had shot at least one black bear. (Carrie knows this as a fact, since she was in possession of the bear rug for many years. She often tripped over its head in her home, and finding the presence of the rug rather disquieting, she eventually dug a hole in her yard and gave the aged bear a proper burial. But that was many years after this story took place.) The outraged sheriff tracked the gypsies down before they left town and did, in fact, find his son among them. The sheriff then let them know in no uncertain terms that they had best not return. He took his son home with him, saving him from the uncertain destiny of a traveling gypsy fortuneteller.

## THE MYSTERIOUS ALICE GORMAN: THE WEALTHY PAUPER

*From an interview with Joanne Larson of the Gorman Foundation.*

Tucked away in the small city of Sherrill, there is a charitable foundation started by Alice Gorman that donates generously to an assortment of local causes. Surprisingly,

few in the area happen to know who Alice Gorman was, and many do not yet know of the Gorman Foundation.

Alice's mother died when Alice was only ten years old, and Joanne Larson's mother, Mary Rose Durfee, took her in and reared her like a daughter. Alice became a big sister to Joanne. She graduated from high school in Camden and later from the Central City Business Institute. Alice had been from a family of nine children, and she was the youngest. Catherine, or Kate as she was called, was the oldest. After graduation, Alice moved to California. Her sister Margaret was working there and had promised to get her a job if she came. Alice got a job at Universal Studios hiring bit actors, and she started to become well known.

Alice was also an accomplished pianist and would perform at conventions. At one point, she performed at a Lithuanian convention, and there she met Dr. Kirstuk. Dr. Kirstuk was a Lithuanian man living in Chicago who had traveled to California to attend the convention. He spoke Lithuanian, and the two of them fell in love. Alice moved to Chicago and married him, but Dr. Kirstuk's mother and sister lived on the third floor of the building, and they did not treat Alice with kindness or respect. For the most part, they believed that it was their duty to take care of the doctor.

Though Alice's family had been poor, Kate, Alice's older sister, somehow managed to attend Cazenovia Seminary, where she was trained to be a finished young lady and a lovely person. However, Kate contracted tuberculosis and went to the Trudeau Institute in Saranac Lake, where she

slept on the open porch as part of her cure. Kate was very literate and would read to others who were recuperating. There she met a cantankerous patient named Owen. She would read to him, and they soon fell in love and were married. Owen Gorman was a corporate attorney in New York City. Catherine moved there with him, devoting her life to him as his wife and secretary.

Owen Gorman was a very unusual man. He accumulated great wealth, primarily in the form of stocks options from his work, and managed them well over time. He slept all day and was up all night. He rarely attended court but would send his wife instead. No one but he and his wife were allowed in the apartment, so nothing was ever repaired. Catherine lived many years as Owen's wife but eventually died, leaving Owen a widower. Catherine had been his lifeline and his caretaker, and with her passing, Owen became suicidal. To help Uncle Owen during his time of loss, the family invited him to Joanne's farm in Sauquoit, and Alice came from Chicago to stay with them for a week. They enjoyed a week together, and then she returned to her husband in Chicago and Owen returned to New York to pursue his legal practice.

Owen Gorman had graduated at the top of his class at Fordham University School of Law, and though he was a brilliant man, he was very much incapable of living on his own. His habits were peculiar. Owen possessed millions, but he watched every penny and purchased nothing for himself, though he was known to give generously to charity. Most

particularly he donated to the Franciscans, with which his sister had an affiliation. Everything in his expensive penthouse apartment was threadbare, and Owen found it difficult to complete tasks as a perfectionist and could never seem to finish work to his own satisfaction. To create order, he would work on a day's projects, which he would not complete, and then when the next day arrived, he would cover them over with newspaper and start on new work. The following day he would do the same, and so the tables bore stacks and stacks of newspapers and incomplete work. Rather than use furniture, he lived out of boxes that were stacked against a wall and covered with sheets. So he would never be without the tools he needed to work, there were staplers everywhere, just as there were paper clips all over and other tools as well. Owen Gorman was an affable man who would sing Irish songs and carry on a conversation in public, but in private he would talk about how he did not like the people he had been with. He did not relish being with people outside of his trusted wife and perhaps a very few others.

When Catherine died, Owen was lost. He called Alice and told her to come to New York—he needed her. Alice's husband allowed this, and she split her time between Owen in New York and her husband, the doctor, in Chicago, leaving her mother-in-law and sister-in-law to care for her husband in her absence. At each location, she would prepare meals in advance and label them so no one would go hungry.

One day, Alice's husband went to Las Vegas and died of a heart attack there. Like Owen and Kate, the couple

Alice was left with all of Owen's effects to sort through in New York. Amanda, Joanne's daughter, went and stayed in New York with Alice in the apartment and found a job in the city. However, after two years, Amanda decided to move to Sherrill. She told Aunt Alice she was leaving and invited Alice to come with her. Alice moved into Joanne's apartment house that is today located in the building in which the Gorman Foundation resides. Though Alice lived in Sherrill, she kept the New York City apartment and would travel there from time to time to settle Owen's estate—there was much to settle.

Prior to Owen Gorman's death, his parents had died, leaving him their estate, but that had not yet been settled either. Owen Gorman had never bothered to probate the will even though he was an attorney. Alice was left to settle not only Owen's estate, but also that of his parents. Perhaps one of the reasons Owen's parents' will was never probated was the microscopic attention to detail and the level of control that Owen felt he needed to have over every aspect of life. Joanne related this story. At their summer house, seldom visited, Joanne realized that they needed a new refrigerator. Owen wrote out a list of questions to ask and comparisons she must make. Joanne had to explore the warranty, the price, etc. Finally, Joanne just picked one, wrote a check and sent him the bill. On phone conversations, he would question her about all the things he had asked and write down the answers. If she misspoke on another occasion, he would quote what she said in the prior conversation. With

this type of micromanagement, it was difficult for anything to be accomplished.

When Alice Gorman was living in Sherrill, she had to work on a will. Many times, she and Owen had attempted to write a will that would distribute the money in a way they saw fit, but like everything else, it never was accomplished. There were many partially written wills. Now the job of disposing of the money fell to Alice, which was one of the reasons Owen married her: to dispose of his money according to his wishes. Alice had inherited everything from Owen, and she would spend the rest of her life working on forming a proper will and setting up a charitable foundation. They had wanted to form a foundation and had originally been interested in donating a great deal of money to the Catholic church, but at the time, there were numerous lawsuits revolving around child molestation by priests and the couple did not wish to contribute money that might simply be used to settle a court case. They had hoped that their money would be used for charitable, uplifting purposes.

In a sense, the foundation was a surprise to Alice's family. Joanne said that she had heard that Alice was forming a foundation, but Joanne did not have a clear understanding of exactly what a foundation was. Both Alice and her sister Kate had been childless, and the foundation was their way, and Owen's way, of distributing their wealth to those in need. The second surprise to the family was the amount of money that the foundation had. They knew Owen had

money but had no idea as to the extent of his wealth. When Alice did die, Joanne had to call a local attorney to locate a lawyer who practiced foundation law. Joanne said she had no idea where to begin. In the will, Joanne and Amanda were chosen to run the foundation, and Jim Sullivan was placed on the board of trustees. Joanne believes that she and Amanda were chosen because they were family members and Owen and Alice trusted them. There were few people that Owen trusted.

Joanne remembers that Alice was loved by everyone, and yet she, like Owen, expressed a lack of trust in people. When Owen Gorman first took his apartment in New York City, it was in a very nice location. They had a wonderful view from their floor, but the make-up of that community changed over time, and it became less safe and desirable, and so Alice became suspicious of people. They never allowed anyone in their New York City apartment except a few family members such as Joanne. Alice's suspicions are illustrated by this anecdote told by Joanne: While Alice was living in Sherrill, Joanne told her that there would be a concert in the park that night by the gazebo. These concerts were a summer staple of the community, and people would come out and sit on the lawn, socialize and listen to the music. Joanne had quite a few errands to do that day so she put the concert chairs for the family in the car, stopped at the park, set up the chairs and was preparing to leave to continue on her errands. Alice told her that she was crazy. Surely those chairs would not be there for that evening! By

then they would be stolen and gone. Joanne listened but left the chairs in place, and they drove off. That evening, Alice was astounded when they returned to the park for the concert and the chairs were in place, right where Joanne had left them. Alice could not believe that someone hadn't stolen them.

Alice had an aversion to doctors. She believed if you went to the doctor's you would be taken to the hospital. Amanda told her that this was ridiculous and had taken her to the doctor on one occasion. Amanda had gone for coffee while Alice had her appointment, but unfortunately the doctor had found that Alice had a heart condition, and she was taken away on a stretcher to the hospital, only reaffirming her belief that a trip to the doctor's would ultimately lead to a trip to the hospital.

While living in Sherrill, Alice was always working with figures. She continued to monitor her accounts to the penny and would call the bank if an account was twenty-five cents off. One day Joanne stopped by, and Alice's head was resting on the table. She had been working on her income tax. It was April 15, and Joanne asked if she needed her income tax mailed. To Joanne's surprise, Alice said, "Oh, no. We still have plenty of time." That was the moment when Alice knew that something was wrong. Alice would never miss filing her tax return. "We'll take care of it next week," Alice said.

Joanne took her to the doctor's and found that there was a lump between her breasts and that the cancer had spread

to Alice's brain. Apparently, Alice had known about the lump for some time, but when Owen was alive, she had not gone to the doctor, not wanting to leave Owen alone. She did go after he died and had been taking medication for the lump.

Joanne remembers the day of April 15, 2002, when she took Alice to the doctor. Dr. Burdick said that the cancer had spread to her brain. He asked Alice if she knew what was wrong. "Yes," she said, "I have the big 'C.'"

During treatment, Joanne would take Alice to the radiologist. She remembers Alice was wearing one of Owen's T-shirts. Owen had to have everything very soft and so had liked old T-shirts. Alice was wearing his old ragged T-shirt and some worn shorts. The medical workers must have felt that she was a poor, homeless woman, and when they put her in a wheelchair, they put bags of samples of the cancer medication in her lap. The medication was very expensive, and Joanne was too embarrassed to tell the medical staff that Alice was not poor. Alice Gorman died on June 6, 2002. Joanne says that the reason the foundation likes to support cancer research and funded the Alice M. Gorman Imaging Center in Oneida is to repay them for their kindness to Alice.

Joanne knew that there would be a foundation, but Amanda knew nothing about these plans. The foundation was funded with an extraordinary $23 million. When Owen's parents' probate was completed, the foundation received an additional $1 million from their will.

Though the Gormans would be mortified to find their names immortalized on buildings and in other ways, Joanne enjoys preserving the memory of Catherine, Alice and Owen. They were childless, and so through the foundation Joanne and Amanda are able to find ways to create great works that stand as a memorial to them. Catherine Cummings (Cummings was Kate's maiden name) had graduated from Cazenovia College and had been active in the theatre while there. The Gorman Foundation refurbished the theatre, and now it is called the Catherine Cummings Theatre. The foundation contributed $1 million for scholarships. The college, in return, found Catherine's old yearbooks and pictures of a play she directed called *The Little Clod Hopper*. In commemoration of Catherine Cummings and the foundation's very generous gift, the school created a performance of *The Little Clod Hopper* in memory of Catherine Cummings since she worked at the theatre when she attended Cazenovia College.

The Gorman Foundation has also contributed $1.2 million to make the Alice M. Gorman Imaging Center in Oneida a reality. This not only preserves the memory of Alice Gorman, but also serves as a thank-you to those who tried to help Alice survive her cancer.

The Gorman Foundation has contributed $2 million to Fordham University in New York City, where Owen Gorman attended law school. There the Owen Gorman Moot Courtroom will be constructed. Groundbreaking begins in the fall of 2009.

While the Gorman Foundation does most of its charitable giving very close to home—in the Sherrill area and in the areas closely surrounding it—the foundation is not technically geographically restricted. As in the case of Fordham University, it sometimes chooses to give in other areas. Recently, the Gorman Foundation has decided to make contributions to a few Lithuanian causes, honoring Alice and Catherine's Lithuanian heritage.

## SOME SHARP KIDS

In the 1965–66 yearbook for Waterloo's high school, there is a striking picture of a group of students, a teacher and an advisor. The group represents the school's rifle club that worked to develop safety, good sportsmanship, competition and proficiency in the use of firearms. The school had a firing range located in the basement, and the students brought their rifles to school and stored them in their lockers on match days, on which they competed with other schools.

## WATERLOO'S BIGGEST CHICKEN BARBECUE

In 1951 in Waterloo, a woman's garage caught fire. The chicken coop was behind the garage, and she lost 250 chickens that day at her home on Route 96, known as Virginia Street. Locals call it the village's largest chicken barbecue.

## HITCHING A RIDE

Years ago there were large rail yards in Utica, and the young boys would often hitch a train to Herkimer or Little Falls to see their girlfriends. In the rail yards, the trains would be stopped or moving slowly, enabling nimble young people to jump aboard and sneak into boxcars to hitch a ride to wherever.

## LOUISE M. SCHERBYN: WOMEN'S MOTORCYCLE PIONEER

Perhaps one of the most forgotten and yet remarkable personalities in New York was Louise M. Scherbyn, born in and a lifelong resident of Waterloo, New York. Louise's first motorcycle ride was on her husband George's 1932 Indian Pony motorcycle during their honeymoon to the Muskoka Lakes in Ontario. She was immediately taken by the experience, and though George ceased to ride a few years later, Louise continued with a passion. Louise purchased her first bike, a slightly used twin-cylinder Indian, for seventy-five dollars, and she continued to ride Indian bikes throughout her riding career.

Scherbyn participated as a motorcyclist in the first All-Girl Motorcycle Show in America held in Waterloo in September 1940. Louise's interest in motorcycles extended beyond herself. She became very active in the

Motor Maids of America, the first women's motorcycle club in the United States—holding membership number six. Scherbyn designed decals and uniforms for the Motor Maids, and she maintained correspondence with members. She served as its secretary for a few years, until she was forced to leave the organization due to conflict with members on the board. Louise Scherbyn was not always an easy person to work with, but she was a hard worker and did her best to help female bikers across America. As secretary, she would receive postcards from women across the United States with their motorcycling mileage scrolled across the back.

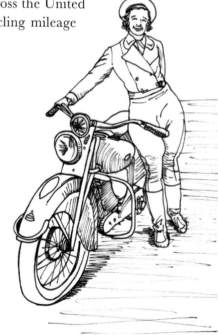

Over the years, Scherbyn participated in numerous biking contests in the United States and abroad, particularly in Canada but in Europe as well. One of her most remembered moments was when she laid out a Hare and Hound chase with herself as the clever Hare. She is believed to have been the first woman to have organized this type of chase, and she

managed to evade the riders at the fifty-mile finish line for a good hour by hiding herself and her bike beneath the canvass in the bed of a pickup truck parked by the side of the road.

Scherbyn raced in endurance races and led numerous parades. She was also known to perform stunts on her bike. Once, she rode with six other women on her Indian. On another occasion she performed a stunt with trick rider Putt Mossman. But for all her stunts and contests, Scherbyn also had an incredible record for motorcycle safety, and in 1951 it was said that she had never had an accident in 170,000 miles of traveling. Though she had had spills, she had never been seriously injured.

Scherbyn received numerous biking awards throughout her life and held membership in several biking organizations. In 1950 she formed the Women's International Motorcycle Association and served for more than twenty-five years as its president. She edited the WIMA news and also served as a contributor or motorcycle journalist for a number of other motorcycle publications.

Scherbyn was a true motorcycle enthusiast and kept motorcycle scrapbooks, not just of events in which she participated, but on a wide variety of topics of interest to bikers, and these scrapbooks still exist in the Waterloo Historical Society Archives. She also collected toy motorcycles, and her collection amounted to approximately 350 specimens, which were eventually

given to the Indian Motorcycle Hall of Fame in Springfield, Massachusetts, after her death. During life, however, her home on Main Street in Waterloo served as a mecca for cyclists from near and far. She and her husband George would invite visiting cyclists to their home, and Louise would entertain them with her scrapbooks, toy bikes and good conversation. Her hospitality was known throughout the biking world.

Louise M. Scherbyn died on June 18, 2003, and was buried at the Maple Grove Cemetery in Waterloo. Many of her possessions were donated by the family to the Indian Motorcycle Hall of Fame, to which Scherbyn had been inducted as an honoree. Later, the family discovered additional materials belonging to Scherbyn, including her scrapbooks, numerous papers and photos, as well as artifacts from Scherbyn, the Motor Maids of America and the WIMA; these were donated to the Waterloo Historical Society Archives.

## ONE HOT RIDER

The first motorcycle club for women may have been started in the 1940s, but earlier women were not always averse to getting on a bike. Constance Huber took to riding around the turn of the twentieth century. At first she rode in the front of the bike and, later, behind. Unfortunately, on the second trip, she wore a long,

elegant raccoon fur coat that hung down below the exhaust pipe. The coat caught fire during the ride and never quite looked the same again.

## The World's Largest Puzzle

The Oneida Community in Kenwood, City of Oneida, New York, created the world's largest puzzle for its time in 1927. It was five feet, one and a half inches by six feet, nine and a half inches, and it contained ten thousand unique pieces. The production of the puzzle cost $150.

The project was the brainchild of Ray and Pierrepont Noyes, but the project was not as easily materialized as they had hoped. The first stumbling block was the lack of an image large enough for a puzzle of great size. At last Eddie Bedford obtained a twenty-four-sheet poster. The puzzle itself contains three sheets that together depict West Point.

Once the lithograph was procured, Pierrepont and Ray drove to Salem, Massachusetts, to speak to craftsmen regarding the manufacture of the giant puzzle, but they were told that it couldn't be done. One problem was that there was no veneer available that was large enough to make the puzzle. Another difficulty was that the shop machines were not capable of the job. Still, Pierrepont and Ray were not deterred. They had a veneer of appropriate size made using Oneidacraft tools and cut it into twelve sections. The sections were shipped to Salem, cut into

ten thousand unique pieces and then shipped back to the Oneida Community in two bushel barrels.

The community began piecing the puzzle together on August 15, 1927, and it was not finished until February 15, 1928. All in all, they labored 2,500 hours to complete it. The puzzle was so large that the community had to commandeer several vacant rooms and in them assembled assorted card tables, camp chairs, long tables and sawhorses to support the mammoth operation. No pieces were lost. The final piece, quite diminutive in size, was put in place in front of an audience by Ray and Pierrepont, each holding a side. Later, the puzzle was glued to a backing and hung in a frame in Ray Noyes's office. The puzzle may be currently viewed framed on a wall in the Mansion House.

## FINISHED AT LAST

Historically, Dr. J.W. Day had a stock farm on Route 96 South of Waterloo. It was rather extensive and included a twenty-box stall, a stallion paddock and an exercise yard. The famed Seneca Patchen, a trotting stallion, lived in this yard near the village. Seneca Patchen was born in 1863 at Peck Slip. He was sired by George M. Patchen, known as one of the fastest horses among his contemporaries. Seneca Patchen was a handsome horse of black chestnut color and stood fifteen and one-fourth hands high. The horse passed through four owners before Dr. Day purchased him, and the

horse, a trotter, had not been trained for speed consistently. Nonetheless, the horse proved a champion, trotting below 2:30 with a racing record of 2:23.5. He earned Dr. Day $15,000 over an eleven-year period. When he was nineteen, rather on in years for a horse, Seneca Patchen won in Geneva with 2:28, and it is told that the horse was pulled to a walk under the wire to save face for the other horses. Patchen ran the first half mile in 1:14.

While Dr. Day was away on a trip to the west, Seneca Patchen died at age twenty-nine in July 1891. To honor his great speed, he was buried on the southern side of the finish line at Maple Grove Fairgrounds Racetrack in Waterloo, New York. He was laid to rest with his nose to the wire as he had finished so many times in life. It is said that a stone monument marked the grave, but those in the know believe it is now gone.

# ABOUT THE AUTHOR

Melanie Zimmer is the author of *Myths, Legends and Lore: Central New York and the Finger Lakes* and also has written for various encyclopedias and magazines. She performs puppetry as Dancing Bear Puppet Theater, and also performs storytelling in New York State and around the country. She is a member of the League for the Advancement of New England Storytelling and the New York Folklore Society. You may visit her website at www.thepuppets.com

Visit us at
www.historypress.net